SOUTH SHIELDS
MURDERS &
MISDEMEANOURS

LAURIE CURRY

AMBERLEY

THE BRONTË'S WRITE HAND
A MIGHT OF WORDS

First published 2000 by The People's Press
This edition 2008

Amberley Publishing Plc
Cirencester Road, Chalford,
Stroud, Gloucestershire, GL6 8PE

www.amberley-books.com

British Library Cataloguing in Publication Data.
A catalogue record for this book is available from the British Library.

ISBN 978 1 84868 177 4

Typesetting and Origination by Diagraf (www.diagraf.net)
Printed in Great Britain

CONTENTS

ACKNOWLEDGEMENTS

I would like to thank everybody who has helped me with this book. The first must be the woman I love, my wife Jacqueline, who helped with the research and who has more faith in me than myself. Also, my thanks go to my children Zoë and Matthew who have, most of the time, given me peace and room to write. I still love them.

I would like to thank Colin Brown of YMCA Training for the computer training he gave me. I would also like to thank the *Shields Gazette* for the source material, alongside the South Shields Central Library's Local History Section for all their help and knowledge. Also, thanks must go to Mr Duffy of Grunhut, Makepeace and Duffy (solicitors) for the photograph of Mr Grunhut. I would also like to extend my thanks to the South Shields writers' group, The Bronte's Write Hand.

For providing photographs, I would like to acknowledge the following: Ken Banks, John Carlson, Joyce Carlson, George Nairn, North Eastern Police History Society, the Wingfield family, Harry Wynne and John Yearnshire.

INTRODUCTION

'We never needed to lock our doors in the past ... Our door was always open, even if we were out. ... You could walk the streets safely in those days ... Nobody bothered you.'

The above is what I used to hear my grandmother say when she was comparing my 'times' with her 'times'. It is still being said today by my generation. I believe it will possibly be said by the next generation to come after ours. Is this a perpetual myth passed from generation to generation, or is it that by the time we reach old age we forget all the troubles in our past? It could be nature's way of easing our mind in old age with the happy knowledge that we lived our young life in the 'good old days'.

I started to do some research to find these good old days of South Shields by trawling through the archives of the local history section of the Central Library in South Shields. I also went through the back copies of the *Shields Gazette*. I was looking for the 'ordinary' Shields person, not the rich and famous. What I found confirmed my thoughts, it was not all good old days, and there were quite a lot of bad old days too. Enough to make me happy I was not living in those good old days.

Local history contains many aspects of society. It is interesting to read about people and their achievements, how the town was advancing, the local politics etc. Amongst these there is one subject that stands out amongst them all and which always seems to grab the readers attention immediately. That subject is CRIME! Why that is so I have no idea, all I know is that I am no exception. My attempts to do a 'good old days' book flew out of the window as I was consistently drawn to the shocking headlines heralding a crime being reported. The *Gazette* in those days certainly knew how to arouse you curiosity and keep your attention. My curiosity was certainly aroused and I could not even attempt to ignore the headlines that were used.

This book is a result of that curiosity. I had to start and end somewhere and also to choose which criminal subject. So, I started at the turn of the last century, 1900, and ended at the quarter century. Researching twenty-five years on the criminal element was enough to satisfy my curiosity, until the next book. The main subject I chose was ... Death!

I have included throughout the book short snippets taken from the *Shields Gazette* from the period. These are to show that the courts were also dealing with the lighter side of life as well as the tragic.

Laurie Curry

THE SOUTH SHIELDS CANNIBAL

DECEMBER 1903

The headlines in the *South Shields Gazette*, 27 January 1904, would not seem out of place today, that is, in a paper such as the *Sunday Sport*.

'Alleged Cannibalism...
A Dying Woman's Deposition.'

Cannibalism in South Shields in 1904? A half-eaten woman? The headlines conjure up some pretty nasty images, yet the story behind them is pathetic and tragic and all too common at the turn of the century. Who really is to blame?

This tragic and ugly incident took place on the 28 December 1903. The time of good cheer and good will. That is for the people out there who were well off to have good cheer and good will over the holidays. For those that had to work to make a living in poor circumstances, the cheer and good will came in short little bursts between work or in some cases it never came at all. The Anderson family were amongst them that it never came at all.

Eleanor Anderson, a fifteen-year-old girl, was working on the family's fruit stall in the town's Market Place. Helping her was her fourteen-year-old friend, Isabella Jerry. Isabella had been staying at Eleanor's home at 17 East Street for three weeks while she helped out on the stall. These were the days when the Market Place stayed open until at least 10.30 pm and was the focal point of South Shields. It was situated on cobblestones in the form of a square and in the middle was the town's Town Hall and the market place surrounded this building. The streets' surrounding it consisted mainly of public houses and just off the Market Place was the riverside with its docks and ship repair yards. Also the North Shields & South Shields ferries.

There would have been a lot of hustle and bustle going on, people shopping for the night's supper or tomorrow's meat, mingling with the drunks, seamen off the ships with money burning holes in their pockets, thieves and prostitutes showing a willing hand to take it from them. The homeless, the poor and destitute, the well off, the young and old all ground together to form a thriving mass of townspeople. The stalls manned by people trying to shout out their wares with other stallholders in competition with them. The wares on display, lit up with faded yellow glows from the one small oil lamp and the ones, which were brilliantly lit with a profusion of oil lamps where the stallholder could afford it. It may look good on a pretty picture postcard but it could be a rough place to be at night.

1

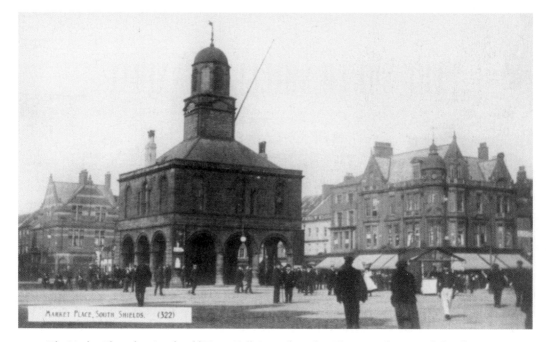

The Market Place showing the old Town Hall. It was here that Eleanor Anderson traded on her family stall.

You might not, today, want your fifteen-year-old daughter to be in the Market Place at this time of night only accompanied by her fourteen-year old friend, saying 'they have no business there'. Well, in 1903, that is exactly what they had, a family business, and it was not unusual to see people younger than Eleanor running a business. At an early age you worked at anything at anytime to make a living. Eleanor was lucky, she had her friend helping and also Walter Hewson, a hawker, and to look after her if needed.

About 10.45 pm Eleanor and Isabella decided to pack the stall up. Walter Hewson gave them a hand to do this and also helped them to carry the fruit that was left to Eleanor's home.

While they were packing the stall up, Archibald Anderson, Eleanor's father came to the stall. He had obviously had a drink or two as he was quite drunk, Isabella was to say later 'very drunk'. When they arrived at 17 East Street, which was just a few yards from the market, the Anderson's home, Eleanor asked her father to give her a hand to carry the apples upstairs. A few argumentative words were exchanged with the result that Archibald Anderson went upstairs without carrying anything. Eleanor followed her father upstairs and told him that if he would not carry anything then neither would she. An argument broke out between them, Eleanor moved to go into the kitchen but her father stopped her by grabbing hold of her hair and they both started to struggle. At this point, Susannah Anderson, Eleanor's sister, intervened, only to have her hair grabbed by the father. The mother, Susannah Anderson, came to the girl's rescue and she herself began to struggle with her husband. The father then let go of his daughter's hair and began to fight with his wife.

In his drunken state he began to get the worst of it all, even sober against his wife it would have taken all his strength, as she was a very stout woman. It did not take long for

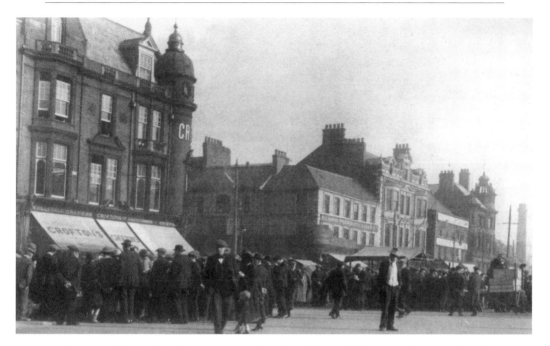

Another view of the Market Place. No matter what day of the week, there were always people milling about. Today, the Market Place is usually deserted except for market days.

his wife to get the better of him; she had grabbed his beard and begun to tug it wildly. It was at this point that Archibald Anderson bit his wife's finger, thus putting a stop to the fight. Mrs Anderson shouted 'he's bit me,' promptly sat down and fainted. This was likely more through exertion than the bitten finger. Mrs Anderson quickly recovered her senses, and when things had quieted down she put a poultice on her finger and dressed it. In the meantime Isabella Jerry had ran to the police station and asked for a constable to go to 17 East Street because of the trouble. An officer accompanied her back to the house. When he got there Mrs Anderson told the officer what had happened, and showed him her finger. Mr Anderson remained silent. It is not reported what the police officer said, but it is more than likely he gave a caution, then left thinking that it was just another of the many family squabbles that he had to attend to on his normal patrol.

The next morning Mrs Anderson was concerned about her finger and went to visit Dr Harland at his surgery in Chapter Row. She told him how it had happened and that she was in a great deal of pain. Dr Harland dressed the wound but did not think that it was a very serious wound. Two days later Mrs Anderson again visited Dr Harland, who once again looked at the wound. There was some inflammation about it but he did not think it was any better or worse than the last time he had seen it and that it was not a serious case. He did not tell her to do anything to the wound and did all the dressing of the wound himself. On the 4 January 1904, Susannah Anderson became more concerned about her finger, by this time her whole hand was swollen; she visited the Ingham Infirmary for advice. She was seen by Dr Sevel, house surgeon, who attended to her as an out-patient for two days before admitting her to the institution on 7 January, suffering from a poisoned hand caused by the wound over the knuckle of the little finger. Several operations were done but her condition was deteriorating fast.

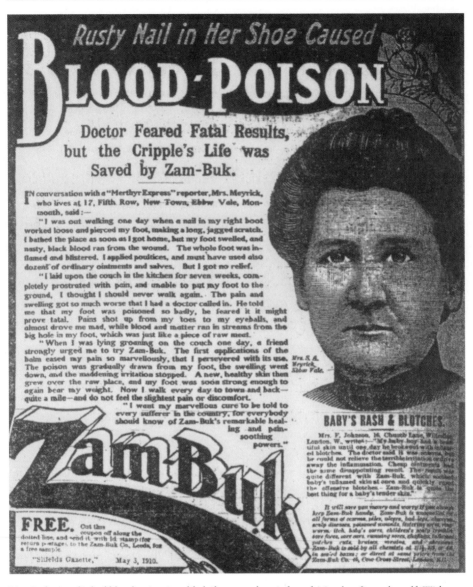

Rusty Nail in Her Shoe Caused

BLOOD-POISON

Doctor Feared Fatal Results, but the Cripple's Life was Saved by Zam-Buk.

IN conversation with a "Merthyr Express" reporter, Mrs. Meyrick, who lives at 17, Fifth Row, New Town, Ebbw Vale, Monmouth, said :—

"I was out walking one day when a nail in my right boot worked loose and pierced my foot, making a long, jagged scratch. I bathed the place as soon as I got home, but my foot swelled, and nasty, black blood ran from the wound. The whole foot was inflamed and blistered. I applied poultices, and must have used also dozens of ordinary ointments and salves. But I got no relief.

"I laid upon the couch in the kitchen for seven weeks, completely prostrated with pain, and unable to put my foot to the ground, I thought I should never walk again. The pain and swelling got so much worse that I had a doctor called in. He told me that my foot was poisoned so badly, he feared it it might prove fatal. Pains shot up from my toes to my eyeballs, and almost drove me mad, while blood and matter ran in streams from the big hole in my foot, which was just like a piece of raw meat.

"When I was lying groaning on the couch one day, a friend strongly urged me to try Zam-Buk. The first applications of the balm eased my pain so marvellously, that I persevered with its use. *Mrs. S. A. Meyrick Ebbw Vale.* The poison was gradually drawn from my foot, the swelling went down, and the maddening irritation stopped. A new, healthy skin then grew over the raw place, and my foot was soon strong enough to again bear my weight. Now I walk every day to town and back— quite a mile—and do not feel the slightest pain or discomfort.

"I want my marvellous cure to be told to every sufferer in the country, for everybody should know of Zam-Buk's remarkable healing and pain-soothing powers."

BABY'S RASH & BLOTCHES.

Mrs. F. Johnson, 16, Church Lane, Willesden, London, W., writes :—"My baby boy had a beautiful skin until one day he broke out with inflamed blotches. The doctor said it was eczema, but he could not relieve the terrible irritation or drive away the inflammation. Cheap ointments had the same disappointing result. The result was quite different with Zam-Buk, which soothed baby's inflamed skin at once and quickly drove the offensive blotches. Zam-Buk is quite the best thing for a baby's tender skin."

It will save you money and worry if you always keep Zam-Buk handy. Zam-Buk is unequalled for all forms of eczema, piles, ulcers, bad legs, abscesses, scalp diseases, poisoned wounds, festering sores, itch, baby's sores, children's scalp troubles, sore faces, sore ears, running sores, chafings, inflamed patches, cuts, bruises, scratches, and abrasions. Zam-Buk is sold by all chemists at 1½d, 6d, or 4d, in sealed boxes, or direct at same price from the Zam-Buk Co. 46, Cross Cross Street, London, E.C.

FREE. Cut this coupon off along the dotted line, and send it, with 1d. stamp (for return postage), to the Zam-Buk Co., Leeds, for a free sample.

"Shields Gazette," May 3, 1910.

Mrs Anderson died of blood poisoning, likely because she tried poulticing her finger herself. With advertisements like the above people did tend to treat themselves, with the false knowledge that these products were more effective than a doctor.

Detective Inspector Sanderson, acting on information he had received, went to the Ingham Infirmary to see the injured Susannah Anderson, and was told by the doctor that the woman was seriously ill. After interviewing the woman he made urgent plans for a statement to be taken from her that same day. He then went to 17 East Street where he had an interview with Mr Anderson. He told the husband about his wife's critical condition and that he had arranged for a statement to be taken from her. Detective Inspector Sanderson then asked Anderson to accompany him to the Ingham Infirmary to witness the statement

BOARD OF HEALTH

NOTICE.

The Public are respectfully invited to communicate every possible Information as to Nuisances existing in their Neighbourhood, so that the same may be immediately removed.

JAMES BUGLASS,

INSPECTOR.

Police Station, September 19th, 1853.

South Shields; Printed by R. M. Kelly.

The police station issued these kinds of notices in the early part of 1900. The outbreaks of scarlet fever were quite high but not everybody was inclined to go to hospital, thereby containing the disease. This may have e been mainly because they had to work, or find work to keep the family on what little they had and in poor housing conditions. Public information was relied upon to remove these people to a proper hospital before they could spread their disease further.

being taken and told him that he could cross-examine his wife if he so wished. That same evening, at the Ingham Infirmary, the magistrate's clerk, before Ald Wardle, a Justice of the Peace, took the dying woman's statement. Present were her husband and Detective Inspector Sanderson.

Susannah Anderson, on her oath, gave the following statement:

'On the 28 December 1903, I was in my own house about five minutes past eleven o'clock at night. My husband was also in the house. He was badly using my daughter (not yet sixteen). He was pulling her hair. I was trying to undo his hand out of her hair when my husband bit my finger. He gave me an awful bite; his teeth cut right through to the knucklebone. It was the little finger of my right hand. I used poulticing from that time until I got into the Infirmary. I had seen Dr Harland before I came here. He dressed my hand twice before I came to the Infirmary.'

Archibald Anderson was asked if he had anything to say. He stated that his wife was pulling him along the floor by his beard and had provoked him into biting her. Susannah Anderson, in her statement, railed: 'I did not get my husband by the beard and pull him along the floor. I gave him no provocation for biting me.' At the end of the statement she added: 'I firmly believe I am dying.' Archibald Anderson was then arrested on a charge of unlawfully wounding his wife and was taken into custody.

5

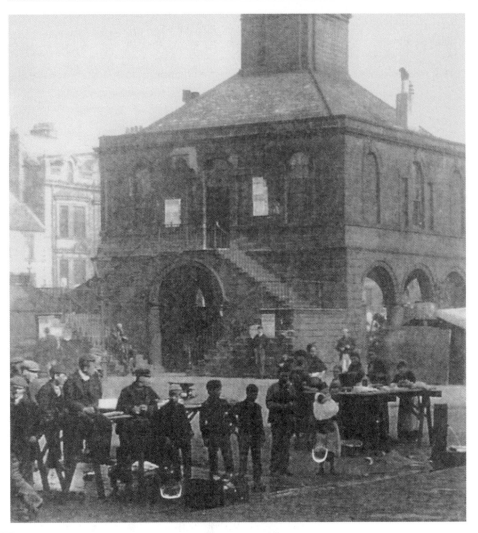

Market Place on what looks like a non-market day showing a couple of tables erected for an occasion.

On the 28 January 1904, Susannah Anderson died. Dr Sevel carried out a post-mortem on the body. He said that the body was extremely obese, and the deceased had a hernia and was not in a healthy condition. Death was due to blood poisoning of the right arm. If her condition had been better than it was, she might have lived. Archibald Anderson was now charged with causing the death of his wife by biting her on the finger.

An inquest was opened before the South Shields Magistrate on 29 January. Eleanor Anderson, the deceased's daughter, gave evidence of the events that had happened on the 28 December 1903. After she had finished, Deputy Coroner, Mr A.T. Shepherd, asked the prisoner, Archibald Anderson, if he had any questions to ask.

Prisoner to witness: 'Ellen, have I not been a good father to you all my life until that fateful moment?'

Eleanor Anderson at this point burst into tears and replied 'Yes.'

'Don't cry my lass. Did you ever know me correct you or strike you?'

'No.'

'Did you ever know me to have a row with your mother or commence one?'

'No.'

'Don't you think that if your mother had gone to the Infirmary at first she would have been all right?'

The Deputy Coroner: 'She cannot answer that question.'

The enquiry was then adjourned until 2 February to allow medical evidence to be called. At the resumed inquest, Dr Harland of Chapter Row, gave his evidence. He stated that Mrs Anderson had come to his surgery with a bleeding hand and told him that her husband had bit her little finger. He had dressed the wound and two days later had dressed the wound again, and after this he had not seen Mrs Anderson again. He did not think that the case was a serious one and was unable to say what had caused the blood poisoning. It may have been the bite or it could have been the poultice, which the deceased had applied herself. Or it may not have been the bite at all.

Dr Sevel, when giving evidence, stated the post-mortem findings but could not say positively that it was the bite that caused the blood poisoning.

Mr Grunhut, for the defence, said that there was no case to answer and that in a case of murder or manslaughter it must be proved that the accused caused the death of the person.

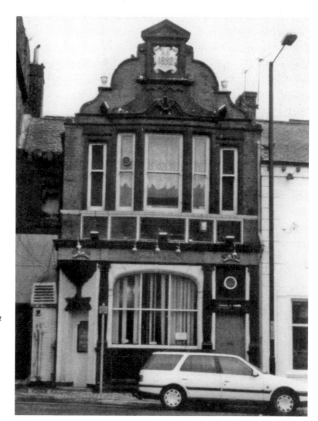

The car in the picture dates the photograph from this era. Remove the car and the Lambton Arms, East Street, is about exactly as it was in the year 1903. Archibald Anderson lived in the same street, so it would have likely been where he would have drank. Today it is better known as the 'Smugglers'.

In this case, the medical evidence was as much in favour of the accused as against him and he was confident that no jury would convict Mr Anderson of manslaughter.

The Magistrates committed the accused to stand for trial and allowed bail of twenty-five pounds and two sureties of ten pounds each. At Durham Assizes, 27 February 1904, the Grand Jury threw out the Bill against Archibald Anderson, meaning there was no charge to answer to.

So, there was no cannibalism or half eaten woman, just a tragic family squabble with drink at the root of it. Archibald Anderson was no mad killer; the real killer was ignorance of hygiene. In modern times, even if the finger had been bitten right off, it is highly unlikely that you would die of blood poisoning with proper medical care. In those days though most people attended to their own wounds when not seriously injured, and if they were ignorant of hygiene then it could prove fatal. Even a minor scratch with a rusty nail could prove fatal.

It is likely that Mrs Anderson took it upon herself to dress her wound because of the financial outlay that it took to visit a doctor and receive treatment. With no health service, being ill could be very expensive that was beyond the means of the poorest of the town. Because of the ignorance of hygiene and the spread of germs any old cloth would be used to dress a wound no matter how serious. A bite to the finger would not be classed as a serious incident at the time. If the wound had started to turn green then a 'poultice' would be tied around it to draw the poison out. The poultice most probably would have been hot wet bread applied to the wound and covered with a cloth. Some times the wound would heal by itself anyway with the poultice having had no effect but the poultice would have taken the credit.

The seriousness of not being able to afford regular contact with a doctor to get a wound professionally cared for most probably led to Mrs Anderson waiting until the infection to her wound spreading to her whole hand to such an extent that the blood poisoning had spread and become too advanced to treat.

DEATH BY PRIDE

FEBRUARY 1905

This case has been included, not because of the suspicious circumstances of the case, but because it shows another set of circumstances that can lead to the death of a person. In this case, like the case on 23 April 1906 death was by starvation, with neglect being the cause. Pride is the circumstance in this case and lack of pride was the circumstance in the later case.

There were other deaths in South Shields in the early part of the twentieth century due to starvation. There seems to be two main links as to the cause of the starvation; pride being one, and the lack of pride being the other.

A coroner's inquest was held on the 13 February 1905, to inquire into the death of 65-year old Andrew Kelso, who died of starvation. The main witness was his widow, Mrs Margaret Kelso.

Mrs Margaret Kelso, an elderly person of a clean and tidy appearance, confirmed that the deceased was her husband and that they lived together at 16 Back Hill Street, South Shields. She stated that her husband had been out of work and that they had no money for long periods of time, apart from the odd copper or two that he brought in when he found casual work. This was all they had to live on and as a consequence had very little to eat. On the day of his death, Friday 10 February, he had left their home at nine o'clock in the morning to look for work. He had not had any breakfast as they very rarely had breakfast. On the mid-day he came back with three pence, which enabled them to buy some tea and something to eat. At about twelve forty-five, Mr Kelso went back out again and she did not see him again until half past six, when he was brought home on an ambulance (normally a flat hand-cart or stretcher). At first he was conscious and when she asked him what was wrong, he replied that he had pains in his stomach. Shortly after being brought home, he lost consciousness and died later the same night.

When asked by Deputy Coroner, Mr A. T. Shepherd, why she did not ask for help from the Parish, Mrs Kelso replied that she did not like to ask for help, as they were proud people. She said that they had seven children who were now grown up. As they had families of their own to support and were also badly employed they could contribute nothing to their parents.

The last time a doctor had been to the house was when Mr Kelso was ill, which was about nine months ago and he had been ill for seventeen weeks before the doctor was called. The Coroner told Mrs Kelso that if she had gone to the Parish she could have got everything she needed. Mrs Kelso said that her husband would not go and that she couldn't go.

PC James Kenton gave his evidence and said that on the Friday night he was on patrol, which took in River Street. When he was walking along River Street he saw Mr Kelso

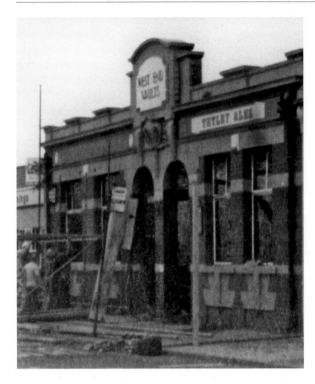

The West End Vaults, Commercial Road – near the corner of Hill Street – the day after it burned down in August 2000. It has now been entirely demolished.

sitting down on the pavement. Mr Kelso was drowsy and seemed to have sunk down. He gave assistance and when Mr Kelso regained consciousness he helped him to his feet. When he was standing up PC Kenton asked him if he could stand on his own. Mr Kelso replied that he was all right, but when the officer let go, Mr Kelso's legs gave way under him. An ambulance was sent for to take him home and Dr O'Callaghan was called.

Dr O'Callaghan, giving evidence, stated that he came to the house immediately and found Mr Kelso unconscious and in a dying condition and that Mr Kelso died shortly after. After he examined the body, and from what he had been told, Dr O'Callaghan was of the opinion that death was due to apoplexy brought about by starvation. He stated that Mr Kelso was a strong man wasted away.

The Deputy Coroner said that it was a very sad case that this could happen to two decent people. He stated that these people belonged to a large class of people who would rather starve than seek aid from the Parish. Their pride prevented them even when illness struck them through lack of food. It is a false notion of pride when it came to saving them from starvation.

The jury gave a verdict of death from apoplexy as the result of starvation. The Coroner gave Mrs Kelso a small sum of money.

Pride was a very strong thing amongst most of the working class population. They do not want to admit that they cannot support themselves and believed that going to the Parish was a form of begging that their pride would not allow. "It doesn't matter what happens, as long as you have got your pride." A sometimes foolish motto to have in certain cases, the above being an example. Another thing that people worried about was that if they could not support themselves then they could end up in the Workhouse. A place to be shunned at all costs.

STARVED TO DEATH

APRIL 1906

On Tuesday evening, 24 April 1906, the Deputy Coroner, Mr A. T. Shepherd, held an inquest at Tyne Dock Police Station, South Shields, into the death of Mary Dixon; a widow aged 65, who had starved to death.

Joseph Dixon, Mary Dixon's son, was employed by the North East Railway Company and was in constant employment, earning 24 shillings a week. He had lived with his mother at 15 Stanley Street, where they occupied two rooms, until the time of her death. He said that his mother had been unwell for about seven or eight weeks and had been in bed for the past fortnight. He did not know what had been the matter with her, just that she was unable to eat, and all she had taken for the past fortnight was two bottles of Bovril, soda, lemonade and whisky. When asked by the coroner if he had called the doctor in, Mr Dixon said that he had not bothered because he did not think that his mother was so bad. He made no reply when the coroner asked did he not think that because his mother could not eat did he not think it serious enough to call a doctor.

When questioned about who had tended to his mother while she had been in bed ill, Mr Dixon replied that he worked night-shift and was at home during the day. During the past few weeks a neighbour had visited twice, also his mother's sister.

Joseph Dixon said that he noticed his mother was getting worse on the Sunday 22. Her speech was becoming unclear and he could not understand what she was saying. On the Monday morning he had come home at one o'clock and gave his mother some Bovril. He then went to bed. At five o'clock in the morning he got up again and gave her a cup of whisky, she had been in the habit of taking drink for about two years. At five minutes to one in the afternoon he awoke again and found his mother dead.

Mr Dixon was asked again why he did not call out a doctor. He was earning 24 shillings a week, he was unmarried and there was just him and his mother to keep. Mr Dixon replied that he did not have the means to afford a doctor and that he had other things to do with his money, also he was in a little debt through his mother drinking. He admitted that he drank himself. When asked to account for his money, he replied that he gave his mother 20 shillings a week. When pressed, he said that for the past six weeks he had given his mother nothing, as she had not been able to go out.

Coroner: 'Then you would have all this money in your pocket. Why didn't you spend some of it in getting a doctor?'

Mr Dixon: 'I have other things to spend it on as well as doctors.'

Coroner: 'You couldn't have spent it better than in getting a doctor for your mother?'

The foreman of the jury, Councillor Luke Scott, asked Mr Dixon if it would not have been easier on his conscience if he had phoned for a doctor. It is a serious matter not getting

CAUTION

ALL POOR PERSONS AFFLICTED WITH

BOWEL COMPLAINTS

Are requested to make immediate application to the

DISPENSARY,

WHERE MEDICINE WILL BE GRATUITOUSLY SUPPLIED.

THE FOLLOWING

SUGGESTIONS AND PRECAUTIONS

Are at the same time recommended to be attended to, under the present sanitary condition of the Kingdom.

Be careful to open your windows and doors several times a day, so as to allow a free current of air to pass through your houses.

Be as cleanly in your persons and houses as you possibly can; and remove at once any filth or dirt, all decaying animal or vegetable substances, such as fish heads, potatoe peelings, rotten cabbage leaves, &c., from your houses, and from about your doors.

Avoid all unripe or rotten fruits, all raw or badly cooked vegetables, and any excess in eating or drinking.

And, above all, attend at once, to any looseness or complaint of the bowels, in however slight a degree, and immediately place yourself under medical care.

LIME for whitewashing your houses, may be obtained by applying to Superintendent Buglass, at the Police Station, Waterloo Vale.

By order of the Board of Health,

South Shields, Aug. 28, 1854.

THOS. SALMON, Sec.

A health notice from 1854. This kind of notice was still applicable in the early 20th century amongst the poor. Medicine would have been given if Joseph Dixon had requested it for his mother.

medical assistance to a seriously ill person. I do not know how you could have stayed in the house and done nothing. Mr Dixon made no reply.

Arm Mitchinson, a widow, living in Gateshead, who was the deceased's sister, gave her evidence at the inquest. She said that she had visited her sister at least once a week for the past few weeks. Three weeks ago she had told the son to call in a doctor. He told her that he would and promised to go. He had been promising for the last two weeks but only did so on the Monday when her sister had died. When asked what excuse the son had made for not doing so, she said he had made none. When asked if she thought the son had neglected his mother, her sister, she replied that she did.

Mr James Gilmoor, a neighbour of the Dixons gave evidence saying that he had last seen Mrs Dixon about five weeks before, and that she was intoxicated and had a jug in her hand. She had a drinking habit and the same could be said of the son. He had on several occasions advised the son to get a doctor in for his mother or he, the son, would get into trouble. The son had said that he would.

Margaret Ann Forster, another neighbour, told the inquest that Mrs Dixon had drank in excess and that she was not a woman to make friends of her neighbours.

Dr F. W. Gibbons then read out his report:

The son called him to the house on the Monday afternoon where he found the body of Mrs Dixon. The body was warm and terribly emaciated. The skin was sallow in colour and dried up. The bones and the ribs at the front were almost cutting through the skin. The haunch bones were also nearly penetrating the skin. The legs were swollen with water and covered with bruise marks or bloodstains, owing to the bad circulation. On different parts of the body were bedsores. The eyes were sunken in their sockets to their extreme depth. The tongue was dry and shrivelled. It was his conclusion that the cause of death was starvation, and that he had never seen a case like it before, it was terrible. The doctor went on to say that even if he had been notified two to three weeks ago about Mrs Dixon he could not have saved her life as emaciation was far too advanced. She should have had attention a long time ago.

Sergeant W. Armstrong, giving, evidence, said that he had heard about the death and visited the house, which he found in a filthy state. On making enquiries about the son at his place of work at the North Eastern Railway Company, he was told by the manager that Mr Dixon had been suspended from work on three occasions for neglecting his duty through drunkenness and that he would never have reinstated Mr Dixon if he had known that he was neglecting his mother.

After all the evidence was given the jury agreed on a verdict of 'Death due to starvation'.

In his summing up, the coroner said that this was a case, which came very close and was on the border of criminal neglect and that the son was the most blameworthy. He also said that the sister of the deceased also had blame attached to her, because if the son was neglecting the mother and failing to get medical attention for her, then she, as a sister, should have taken responsibility on to herself. Taking all the circumstances together into consideration the coroner did not think that the case should go any further, but the son deserved the greatest censure.

The jury returned a verdict of death due to starvation accelerated by excessive drinking and want of medical attention. They recommended that the son be severely censured.

The coroner, when handing over the burial certificate to Joseph Dixon, stated to him that his mother's death was fully at his own door. If he had been a son as a son should have been, his mother would quite possibly be living today. The coroner added that he was satisfied,

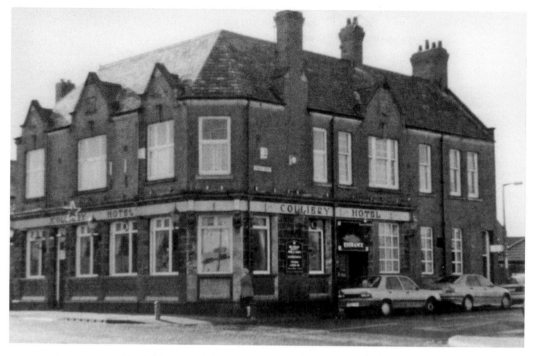

A recent picture of the Colliery Hotel on the corner of Stanley Street, just yards from the Dixon's home and almost certainly frequented by Joseph Dixon. Stanley Street has been totally redeveloped but the pub remains basically the same.

from the evidence that the mother was addicted to drink and was positive that the son was also addicted to drink and that was most probably the reason for the neglect to the mother. He stated that the evidence showed gross negligence and carelessness and that Joseph Dixon had come very close to a manslaughter charge. He hoped the son had learnt a lesson strong enough to make him change his habits, and if any of his relatives ever come into his care that he will not show such inhuman treatment as he had done in the case of his mother.

After the coroner's words, Joseph Dixon left the room without making any remark.

Could this happen today? Yes it could and in certain cases it does. Despite all the precautions put in place to prevent it, Social workers, National Health availability, doctors, and Alcoholics Anonymous etc. cases do fall through the net. Why is this and what can be done to prevent these cases? Neighbours; that is the answer now and was the answer then. Then like now, people do not want to get involved. Even Mrs Dixon's sister did not want to take on any responsibility. Mrs Dixon used to go out to shop and would have been seen to be in a desperate situation before it got that bad she could not go out. Mr Dixon's employer stated that he would have dismissed Mr Dixon had he known that he was neglecting his mother but nowhere does he say that he would have reported him to the authorities. Dismiss him, problem solved.

The neighbours knew about it but all they had done was to warn the son about his behaviour towards his mother instead of getting in touch with the authorities.

Mrs Dixon died a very slow and torturous death by her son's neglect. Could he have walked free today? Let's hope not.

DEATH BY DIRT

MAY 1906

Thomas Murphy of 3 Orange Street, South Shields, gave evidence at the South Shields Police Buildings during an inquest into his mother's death. Thomas Murphy used to be a miner until he had an accident, which left him a cripple. His father, William Murphy was also a miner.

Thomas Murphy stated that last Saturday, 19 May 1906, his mother and father had gone out about six o'clock in the morning. He did not know the reason why they had gone out so early as he was still in bed at the time. He knew his father was not going to work, as he was not due to work that morning.

His father had come back on his own after about an hour and his mother had come back about half an hour after his father. The father had had a drink but was not drunk. His mother though, had come back drunk.

The father had prepared the breakfast and they were both sitting eating at the table when the mother arrived. She sat opposite them and began to sing and mock them, making a nuisance of herself. She then began to thump on the table. Her husband, getting annoyed, picked up the poker that was lying on the fender, having previously been in the fire. He began to wave it towards his wife, telling her to stop making noises and to shut up. According to the son, Thomas, the poker had slipped out of his father's hand and struck his mother across the arm.

Examining his mother's arm he saw a small wound like a burn, which he did not think was serious. He then bandaged his mother's arm and told her to go to bed. As she was very drunk he had to help her to bed himself. At about half past nine, the same morning, Thomas went out and did not return until about three o'clock in the afternoon. In his absence, his mother had gone out for more drink, she said that she had been to a public house. On the Saturday night his mother had poulticed her arm and had made no complaint about her injury until the Monday morning.

On the Monday morning when Mr Murphy came back from work on the dinnertime his wife complained about her arm being sore. Mr Murphy sent for a doctor, Dr Harland, who attended to her up to her death on the following Friday morning.

Inspector George R. Croot, of the NSPCC giving his evidence at the inquest, stated that during his course of duties he had visited 3 Orange Street on 19 May, in connection with the deceased's young children who were on his list for regular visits. The children were in a shockingly neglected state. Mrs Murphy was in bed in a drunken state and was using bad language. Mr Murphy had told him that it was his (Mr Murphy's) fault that she was drunk, as he had taken her out early in the morning and had given her two glasses of whisky. Inspector Croot told Mr Murphy not to give her any more drink. At the time of his visit

A BAD RECORD

July 1904

Sarah Bradley, alias 'Daley', hawker of Reed's Lodging House, East Street, South Shields, made her first appearance at South Shields Police Court, charged with drunkenness in Wapping Street, on the 10th inst. She was fined 5s and costs.

Defendant had a very heavy record, having appeared before the Newcastle Bench 66 times and the Gateshead Bench eight times, and having undergone seven years penal servitude for assault and robbery.

Mrs Murphy had made no complaint about her arm. When he again visited the home on the Wednesday, 23 May, Mrs Murphy was in bed and her arm was bandaged. When he asked her what was wrong with her arm, she replied that she had fell off the table while cleaning the ceiling on the previous Saturday night. Mrs Murphy's father, who was in the room with her, told his daughter to tell the truth. She then said that her husband had thrown the poker at her. Inspector Croot said that the husband was not present at the time that this was being said. He added that he knew Mr Murphy to be a hard-working man and had never seen him the worse for drink.

Dr Harland, giving his evidence, said that he was called in on Tuesday morning and that he had advised Mrs Murphy to go to the Ingham Infirmary for proper attention, which he felt she was not likely to get at home. Mrs Murphy had refused to go. Dr Harland said that the arm was inflamed and that blood poisoning had set in. When he had asked how the injury had occurred Mrs Murphy had told him that her falling on the fender last Saturday night caused it. She did not blame her husband or make any complaint against him. On being asked about the wound, Dr Harland replied that there was a small wound on the arm and that a poker falling on to the arm may have caused it. The son, having previously stated, when questioned, that his mother was addicted to drink and that there was no quarrel between his parents, other than that which occurred at the breakfast table and that he was sure that the poker was not thrown by his father but had merely slipped out of his hand, the jury returned the following verdict. The death was due to blood poisoning caused by a wound to the arm inflicted accidentally by the husband who had no intent to cause death.

THE DELUDED GUNMAN

AUGUST 1906

When the following events were reported in the *Shields Gazette* on Monday, 13 August 1906, it was described as a shocking tragedy and almost without parallel in the annals of South Shields. Even ninety-four years later this still stands true.

The incident took place in an upper flat at Stainton Street, South Shields on the Monday morning of 13 August 1906. Living in the flat at the above address were James Baylis, a River Police officer. He was once a member of South Shields Borough Police, but had resigned this position eight years before to join the River Police. Living with him was his wife Annie, 33 years of age, son Walter, aged 3 years, daughter Olive, 1 year 9 months and his widowed mother, Jane Baylis. Also living in the flat was his brother Walter Lionel Baylis, 33 years old.

Walter Baylis was a chemist by profession and at one time had run a business just outside Morpeth. During the Boer War he had served in South Africa as a trooper, mostly on the front line throughout the war. On his return he had told his brother, James, that he had three horses shot from under him and that the last one had died instantaneously and had went down so fast that, before he could remove his feet from the stirrups, he was thrown over the horse and had injured his head. Walter said that he had spent a week or nine days in hospital because of his injuries. Despite this, James later said that his brother looked the picture of health when he had met him at the railway station on his return from the war.

Shortly after his return Walter's mother, Jane Baylis, visited him in Morpeth. She noticed that he did not seem himself and had been poorly. His brother James, being told this, went to see Walter and persuaded him to move into Stainton Street where he could be looked after. This was about ten months before the tragic events took place.

Walter was put under the care of a doctor who termed his condition as suffering from delusions. He was under the delusion that people were talking about him, outside and inside the house.

After a few weeks at his brother's, Walter seemed to recover a bit and seemed well enough to find employment as a night-watchman at Smith's Dock, North Shields. About five months prior to 13 August, Walter Baylis suffered a relapse that caused his brother, James, concern. James Baylis said that his brother seemed 'funny' and that his delusions had returned, also, that he was a bit afraid of him, even though no threats had been made and his brother was not acting in a threatening manner.

With his fears growing, James decided that the best course of action would be to have his brother Walter taken into the Workhouse Asylum. Walter stayed at the Workhouse for five days and on his return to Stainton Street he seemed to be a bit better and he seemed to be getting better each day. This only lasted for about a fortnight though, after this the delusions came back. Walter was again hearing voices speaking about him.

Smith's Docks across the river at North Shields where Walter Baylis found work as a night watchman.

On the Monday morning at 5.15am of 13 August Walter Baylis returned to his brother's home after finishing work at Smith's Dock. His brother James, who was getting ready for work, opened the door to him. Walter seemed to be in good cheer as he said good morning to his brother, despite his clothes being damp, as it had been raining through the night. Walter went into the kitchen and took off his jacket and waistcoat; he told his brother that he was going to have a lie down on the sofa. He also asked James to tell his wife Annie to wake him up at nine o'clock as he was going to go out and get his hair cut. James Baylis went to say good-bye to his wife and passed on Walter's request. His children were sitting up in bed playing when he left at twenty minutes to six to go on duty.

Shortly after 7am Annie Baylis and her two children, Walter and Olive, got up and Annie made them all breakfast, afterwards she went about doing household chores and looking after the children. At around about 7.45am Jane Baylis, her mother-in-law, also got up. She and Walter had their breakfast together at 9 o'clock, after Annie had woken her brother in-law at 9 am as arranged. All seemed well and everybody was on friendly terms, in fact, it was a morning just like any other. Shortly after breakfast, Walter left the house to go and have his hair cut, and returned soon after.

When he came back, Walter sat around for a while then decided to go back out again to get some sweets for the children. Witnesses who had met him outside at this time later said that Walter Baylis looked and acted perfectly normal. He arrived back at the home around 11.30am. He gave the sweets to the children and sat down in the kitchen. Annie Baylis was working at her sewing machine and the children were playing on the floor. Jane Baylis, presumably, was making the dinner, as her son, James, was due back from his police duties at 12 o'clock for his mid-day meal.

At about 11.45am Jane Baylis went down the back stairs to get some fresh air. While she was sitting on the bottom step she heard a gun being fired in the kitchen. She immediately ran back up the stairs and when she opened the kitchen door, she saw Walter standing with his back to her. Annie Baylis was lying on the floor near her sewing machine. Olive was still in her cradle with little Walter standing near to it. She shouted, 'Oh, Walter, what have you done?' Walter turned to face her but did not say anything. Jane Baylis then ran back downstairs to get help. Before she reached the back door she heard three more shots being fired, followed by a thud like a body falling to the floor. She ran to get assistance from Mrs Russell, a neighbour. Mr Joseph T. Cooke, 209 Imeary Street and Henry Taylor, 52 Marsden

Street, who were also nearby, gave their assistance. They all raced back to the house and went upstairs. When they entered the kitchen a quick glance around showed them what had happened. Joseph Cooke quickly ran to fetch a policeman and a doctor.

PC Wake reached the house within a few minutes of the tragedy. When he entered the kitchen he found the three-year-old boy, Walter, lying on the mat in front of the kitchen fire with his head towards the back door. He was not dead, but was bleeding profusely from a wound to the head. Mrs Annie Baylis was lying on the left hand side of the kitchen window, quite dead, with a bullet wound in the back of the head. She appeared to have been shot from behind as she was sitting working the sewing machine, for she was lying alongside of it, and the chair had gone with her as she had fallen to the floor. Baylis was also dead and was lying in the middle of the floor with a bullet wound through the middle of his forehead. Olive was still in her cradle; she had also been shot in the head and was bleeding, and although unconscious she was still alive.

PC Wake had the two children immediately sent to the Ingham Infirmary while he closed the house and inspected the room. He noticed a revolver lying near Baylis's right hand. It had been loaded with six bullets, five had recently been fired and one bullet was left in the chamber. When PC Wake examined Walter's portmanteau he discovered another nine live cartridges. In another box belonging to Walter he found a box containing nineteen more live cartridges. This box had the manufacturer's name on it, Eley Bros Ltd and had been sold by Messrs Pape, of Newcastle.

Chief Constable Scott, along with Dr Sutherland, police surgeon, and Detective Inspector Bruce arrived at the house shortly after twelve o'clock. After inspecting the bodies of Annie Baylis and her brother-in-law, Walter Baylis, both were pronounced dead. They then went to see the children at the Ingham Infirmary. Both children were dead. They had died shortly after arriving at the Infirmary.

To add to the sadness of the case, James Baylis arrived home for his mid-day meal to find his home surrounded by people and taken over by the police, who had the sad duty to tell him what had happened to his family.

An inquest was opened on the evening of the same day at the Police Buildings, Keppel Street, South Shields. The Deputy Coroner, Mr A. T. Shepherd, said that he was very sorry to hear about the terrible tragedy that had taken place earlier in the day. The first intimation he had had of it was reading about it in the papers on his way to hold other inquests.

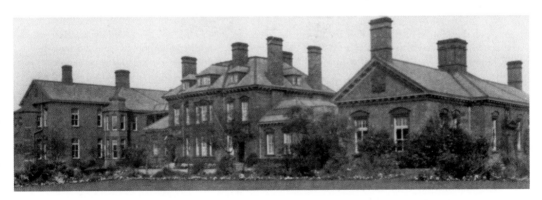

The Ingham Infirmary where Walter Baylis, aged 3 and Olive Baylis, aged 1 year and nine months were taken and later died from gunshot wounds inflicted by their uncle, Walter Lionel Baylis.

Chief Constable Scott had given him particulars to the case and it was his intention, that night, to simply open the inquest and adjourn it for a week so that there would be no delay in the interment of the family. James Baylis was then called to give his evidence.

James gave his evidence of the events that happened that morning before he left for work. He said that Walter was in his usual health and spirits and that he was quite jokey with him. When James was asked if they were all living pleasantly together, he replied that there was never a cross word between them. He stated that he had come across on the six minutes past twelve ferry after he had finished his morning's work. When he had arrived at his home he noticed a crowd of people standing around and then somebody had come up to him and told him what had happened. When he got into his home he found his wife and brother lying in a pool of blood.

When questioned about his brother's health, James said that Walter had been poorly for the last eight or ten months. Also, that he had been in the care of the doctor and had been suffering from delusions and that this was the reason that Walter had come to live with him and his family. James said that about four to five months ago he had Walter put into the Workhouse Asylum. After a period of five days Walter had returned to Stainton Street more like his old self.

At this point, the Deputy Coroner adjourned the case and handed over the burial certificates so that the family funeral could go ahead without undue delay.

At the resumed inquest, 22 August 1906, Detective Inspector Bruce gave his evidence. He stated that he had made enquiries at Messrs Pape of Newcastle, where he believed the revolver had been purchased. The manager had told him that a revolver very similar to the one shown (the weapon used by Walter Baylis) was purchased from him on 17 July. The manager said he could not positively identify the revolver that Walter Baylis had used as one bought from his business as it was a cheap one sold very frequently. On looking at the sale note, the sale was registered in the name of James Baylis. The manager said that the purchaser produced a rent book in the name of James Baylis as proof of identity. The man had also said that he was a member of the River Police and produced a warrant card to prove he was. He also stated that the cartridges could also possibly have been bought at his business. He described the person who had bought the revolver as a tall well-set man, a description that fitted Walter Baylis.

James Baylis was again put into the witness box. In reply to questions put to him, James again repeated that Walter appeared to be better when he came out of the Workhouse Asylum. He said that Walter was getting better every day, more like himself, and that he never noticed anything strange about his brother, nothing to speak of. When asked by the Deputy Coroner what he meant by nothing to speak of, James replied that about a fortnight after Walter had come home, he, Walter, complained about constantly hearing people speak about him. When asked if he had seen the revolver before, James replied that he had never seen it before in his life. He confirmed that he had a rent book with his name and address on it and that he also had a warrant card, which only had his name on, and that he was a member of the River Police.

He was then questioned about his brother's movements on 17 July, the day the revolver was bought. James said that his wife was washing and he was minding the children. His brother, Walter, went out at one o'clock saying that he was going to Laygate Lane to see someone and said that he would be back in an hour. He did not return until four o'clock. James said something to the effect that he had been a long time. Walter had replied that, yes he had, because he had been for a walk afterwards.

Dr Sutherland, the police surgeon, described the wounds each victim received. Annie Baylis had a bullet wound to the left side of her head. Walter Lionel Baylis had a bullet wound in the middle of the forehead. The child, Olive, had been shot through the left temple and the boy, Walter, had been shot twice through the left side of the head.

He stated that in his opinion and what he had heard of Walter Baylis, was that he was a man suffering from delusions and, having been in the Workhouse Hospital under treatment for impulsive insanity, he was a man that could be quite sound and well in the morning, then a sudden impulse could overcome him leading him to do what he did. When the Coroner asked if it was not an uncommon thing for people to kill their nearest and dearest friends, Dr Sutherland replied that it was not at all uncommon. The case where an entire family has been killed is not an unusual case at all.

The Deputy Coroner summed up for the jury and said that they would agree that this was one of the most sorrowful cases that they had to enquire into. He was quite sure that they would all sympathise with the husband who was left without a wife and children. The whole evidence went to show that this was a family who lived on terms of the greatest affection for each other. The last thing Walter did before the tragedy was to go out and buy the children sweets and this act showed his affection for them. The doctor had told them that Walter had suffered from a peculiar phase of the form of insanity and when the impulses came upon the sufferer then that person would seek out his nearest and dearest friends. Walter had probably bought the revolver to kill himself and on that day had it in his pocket at the time an impulse came upon him and that he had turned it on his family then turned it upon himself. It was quite clear what their verdict should be.

The jury found that Walter Lionel Baylis had wilfully murdered his sister-in-law and the two children and then committed suicide, whilst temporarily insane.

THE WORKHOUSE

Even for those in work, like Walter Baylis, the Workhouse Hospital was the only means of treatment for many in the days before the National Health Service.

The following are some extracts from Minute Books of the Board of Guardians of the Poor Law Union.

9th July 1839 – it was reported that in South Shields every tenth person was a Pauper.

20th April 1841 – resolved 'to purchase 20 tons of hard stones to be used by the Able-bodied Paupers in the Workhouse.'

12th March 1857 – A letter from a Sunderland Guardian, in reply to an enquiry stated: 'The means adopted by our Guardians to reduce the number of Vagrants lodging, is simply to '*wash them well*' before going to bed; they are obliged to strip and take a bath. Whilst bathing, their clothes are examined to see if they have any money or other valuables secreted. This is all done before they have anything given to eat, and the result has been most marked. The year before this plan was adopted the average number per week was 119½; the first year it fell to 9¼, and is now 5 per week.' Resolved that this mode be carried out in Workhouse.

In 1880 a new Workhouse was opened at Harton, built at a cost of £48,700. This included a 'Lunacy Block' where Walter Baylis would have been treated.

A letter to the *Jarrow Guardian* in December 1912, from the Chairman of the Board running Harton Workhouse, noted at that time there were 'nearly 1,100 inmates, including about 300 sick, and a number of sick children, and the unfortunate inmates of the imbecile wards.'

1924. MONTH.	MALES					FEMALES					CHILDREN. MALES.					FEMALES					MONTHLY TOTALS.					QUARTERY TOTALS.					Total.
	English	Scotch	Irish	Welsh	Foreign	English	Scotch	Irish	Welsh	Foreign	English	Scotch	Irish	Welsh	Foreign	English	Scotch	Irish	Welsh	Foreign	English	Scotch	Irish	Welsh	Foreign	English	Scotch	Irish	Welsh	Foreign	
January	163	18	16	..	1	29	1	2	2	196	19	16	..	1						232
February	115	12	16	..	1	14	129	12	16	..	1						158
March	157	17	16	2	2	23	..	1	3	2	185	17	17	2	2	510	48	49	2	4	223
April	154	10	29	1	..	28	1	1	..	1	182	11	30	3	..						226
May	194	18	26	24	..	2	218	18	28						264
June	173	24	25	3	..	22	2	1	1	198	26	26	3	..	598	55	84	6	..	253
July	168	11	16	..	2	33	..	3	1	202	11	19	..	2						234
August	175	8	25	1	..	24	1	2	2	2	1	201	12	27	1	..						241
September	152	12	13	3	3	21	1	..	1	..	1	1	175	13	13	4	3	578	36	59	5	5	208
October	148	9	15	1	2	29	1	2	..	1	177	10	17	1	2						207
November	140	9	12	18	..	1	158	9	12	1	..						180
December	110	12	21	1	..	17	..	1	127	12	22	1	..	462	31	51	3	2	162
Total	1849	160	230	12	11	282	7	13	3	..	9	2	..	1	..	8	1	2148	170	243	16	11	2148	170	243	16	11	2588

A table showing the number of Destitute Persons who received Tickets of Admission to the Casual Ward, Harton Union, from the Police during each month of the year 1924. Included is the nationality of each man, woman and child admitted.

In 1925 Parliament decided there should be a major reorganisation of the Poor Law. The Local Government Act of 1929 transferred the functions of the Poor Law Authorities to Councils of Counties and County Boroughs. In April 1930 the Harton Institution and Hospital was taken over by South Shields Corporation.

Part of the Workhouse as it is today.

The buildings, which housed the Harton Workhouse Laundry as it is today. Catherine Cookson (the celebrated Tyneside author) worked as a checker at the laundry from October 1924 until April 1929

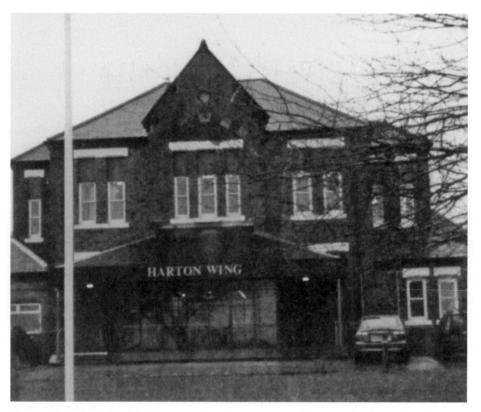

This was the entrance to the Workhouse Infirmary. It is now the Harton Wing incorporated in with the South Shields General Hospital.

A SEAMAN'S TRAGIC FIND

FEBRUARY 1909

Mary Elizabeth Hansen lived at 20 Alderson Street, South Shields, with her lived her husband, Andrew John and their three children, Andrew Ernest, aged 15, Doris Isabella, aged 11 and George William, aged six months.

Andrew John Hansen was a seaman in the Merchant Navy. In January 1909, he was working on board a ship that traded between the Tyne and London; he was earning 30 to 32 shillings per week. On Saturday afternoon on 30 January, Mr Hansen left home to go on board his ship, which was leaving the same day for London. The ship was due back in the Tyne on Tuesday evening, 2 February.

On the ship's arrival back on the Tyne, Tuesday night, Mr Hansen was unable to get home, as it was his turn on watch. Consequently it was not until he was relieved at about 4am on the Wednesday morning that he was able to return to his home.

It was about five o'clock in the morning when he reached his home at 20 Alderson Street. After knocking for some time at the door it was finally opened by his son Andrew. 'What is the matter? Are you all in bed?' asked Mr Hansen. His son replied that he did not know where his mother was. On being questioned, Andrew said that he had not seen his mother since Tuesday night. When he last saw her she was sitting in an armchair in the kitchen. Mr Hansen then searched the house but could not find his wife, nor could he find his youngest son William, the baby.

After searching the house he went out to enquire at some of his wife's friends' houses, as to the whereabouts of his wife. At every place he enquired they knew nothing to help him. He finally returned home about half past seven feeling very uneasy about his wife's disappearance. With his uneasiness growing he decided to look in the wash house, situated in the back yard. On looking inside he noticed the lid of the rainwater well had been removed. When he looked down the well he noticed some clothing. When he touched the clothing he found out it was not just clothes as he first supposed, but a body.

His thoughts became all mixed up. Could this be his missing wife? No, it must be somebody else, yet it had to be his wife. Andrew Hansen could not accept it, the police must be called, and they would decide and know what to do. He went to get his son Andrew and they both went to the police station. He told them of his missing wife and about his find in the wash-house of the back yard.

Sergeant Dickinson and PC Flegg accompanied Mr Hansen and his son back to their home. The two policemen went into the wash house and inspected the well. They confirmed that in fact it was a body and they began to pull it out. On its removal from the well, Mr Hansen's fears were confirmed; it was the body of his wife. There was more horror for Mr Hansen to face, as it was found out that when his wife's body was removed from the well the

A view of the River Tyne showing ships lying mid-river.

police discovered another body at the bottom. It was that of a small baby. William Hansen, six months old, was found. He was also dead.

On the Wednesday evening of the same day, at the Police Buildings, an inquiry into the two deaths was held. The Deputy Coroner, Mr A. T. Shepherd, conducted the inquiry. Mr Hansen was the first to give evidence. He repeated what he had earlier in the day and told the police. He had last seen his wife alive about three to four o'clock on the previous Saturday afternoon, when he had left his home to join his ship. He then related the circumstances surrounding the discovery of his wife. Had she been ill, or had there been any trouble recently? To these questions Mr Hansen replied that he found his wife to be neglectful in her household duties and that the home was always in a very dirty state. He explained that he had tried every kindness to persuade her to look after the house. His wife had said that she would try to do better. He had told her that he would not put up with it any longer as he worked hard for her as any man could. He was asked if his wife had got into any debt. He replied yes, and that there was a great deal of debt. He explained that recently he had been out of work for about three weeks and they had got into a lot of debt for household provisions. When he had started work again he began to pay off the debt. He expected his wife to buy the groceries every week, paying as she went and leaving him to pay off the arrears. He had thought that he had got level again but found out that his wife had been getting into fresh debt again and that there was 26 shillings standing against him. He could not explain why his wife got into debt. She did not drink and he could think of no reason why she could not manage the house. He told the coroner that he earned 30s to 32s per week and had gave his wife 25s and sometimes 27s a week (£1.25–£1.35 in today's money) and that he had been very little out of work Mr Hansen said that his wife had been in a depressed state of mind for some considerable time, that she was in fact a backward woman, and confined herself to the house. She never seemed to go out.

The coroner asked of Mr Hansen if his wife would have been alarmed when he came home. Mr Hansen replied, 'No, I don't think so.'

'Had she ever threatened to take her life?'

'Never.'

'Have you ill treated her in any way?'

'Oh, no.'

Andrew Ernest Hansen, aged 15, employed as an errand boy, gave his evidence. He said that he had arrived back home on the Tuesday night at quarter past ten. His mother was sitting beside the fire. She was very quiet and did not speak. His sister, Doris, was nursing the baby. He went to sleep and heard nothing until his father started banging on the door about half past five the next morning. He shouted to his mother to open the door and receiving no reply, went to open it himself. It was then that he found his mother and the baby missing. He then told of searching the home and going with his father to the police station. He was asked if there was anything troubling his mother, and replied that she had an ulcerated mouth. When asked if there was a doctor attending his mother he replied no.

The coroner asked Andrew if there was any trouble with regard to the house or his father. Andrew replied that there was some talk between his parents in regard to the house being kept dirty and untidy, and that also there were some problems with debt. He said his father never hit his mother but had simply spoken to her and was kind to her. He had never heard his mother say that she would do away with herself and that she was very fond of the baby. He did not know if his mother knew that his father was coming home on Tuesday night. When asked again about the debt he said that there was nobody pressing for payment.

Doris Isabella Hansen, aged 11, gave her evidence, which was similar to her brother's. She said that she had gone to bed on Tuesday night, leaving her mother dozing off to sleep in a chair. When asked if her mother knew that her father was coming home she said yes. She had been sent to the captain's house on the Tuesday to see if her father would be home and that she had told her mother that her father would be home on the Wednesday morning. When asked if her father was kind to her mother, she replied yes.

Sergeant Dickinson and PC Flegg each gave evidence of finding the bodies in the well. The well (a rainwater barrel) was three and a half feet deep with about three feet of water in it. The woman was on her feet with her head under the water and the baby was beneath her. Judging from the bodies, they must have been dead for some time. The doctor that was summoned pronounced both bodies dead at the scene.

The Coroner's Officer, PC Cox, described the living conditions at 20 Alderson Street. Two tenants occupied the house; one upstairs and another occupied the house down. The Hansen's lived upstairs, but at that time the downstairs portion was vacant, and was undergoing repairs.

In his summing up, the Coroner said that it was a very melancholy case and that he was glad there was no reflection on the husband in the evidence. The evidence of both children clearly showed that there was no ill treatment towards the mother. He said that he could understand the husband not pulling his wife out of the well when he first discovered her, but he pondered as to whether life could have been preserved if the husband had pulled the body out before going to the police. He went on to say that it was not a case of accident but appeared to be a deliberate action by the woman. The child being found beneath the mother indicated that the mother must have placed it there. If that was so then it was clearly a case of murder, and suicide in the case of the mother. Evidence from the son and daughter showed that the mother was in a depressed state. The evidence of the girl had shown that the mother had contemplated doing something. He gave his sympathy to the husband.

The jury gave the verdict that Mary Elizabeth Hansen, who subsequently committed suicide whilst temporarily insane, wilfully murdered George William Hansen.

INSANITY

MARCH 1910

The following case bears a remarkable similarity to the ' A Seaman's Tragic Find' case of February 1909. So much so that one can't help thinking that the following tragedy may have been as a result of Susannah Spencer reading about the case and bringing it to mind with the dire result, which follows.

On Wednesday 30 March 1910, Susannah Spencer, aged 36, was charged with feloniously, wilfully and with malice aforethought of killing and murdering her child, Lily Hopper Spencer, aged 9 weeks. She was brought before the South Shields magistrates Ald J. R. Lawson and Mr J. B. Laidler. She was accompanied by one of the police matrons, and was accommodated with a seat in the dock. She appeared to feel her position most keenly, as when the charge was read out she burst into tears.

Susannah Spencer lived in the upstairs flat at 144 Eldon Street, South Shields. Living with her was her sea-going husband, James William Spencer, her daughter Margaret, aged 12 years and her other daughter, Lily Hopper aged 9 months.

Shortly before five o'clock on the morning of Wednesday 30 March, Margaret Spencer was awakened by noises and screaming. She turned to wake her mother but found she was gone, also missing was the baby, Lily. The mother and two children all shared the same bed, the husband being at sea at the time.

The shouts and screaming were coming from the back yard, so Margaret went there to investigate. When she went out into the yard she was horrified to see her mother in the well (a rainwater barrel containing water for household use) clinging to its ledge. Her mother was shouting and screaming incoherently. The well was about four feet ten inches deep and contained about two and a half feet of water. Margaret tried to get her mother out of the well but Mrs Spencer kept a rigid grip on to the ledge.

The shouting and screaming had by this time aroused the neighbour, David Brown, who lived in the downstairs flat. Mr Brown rushed out to help. He managed to loosen the woman's grip on the ledge and pulled her out of the well, he then guided Mrs Spencer into her home. Mrs Spencer was in a very exhausted and agitated state but she managed to make signs to Mr Brown, which he assumed referred to the baby. She kept pointing to the yard but could not speak coherently.

Mr Brown, fearing for the baby, immediately went back to the yard and began a search for the child. He made his way straight to the well to begin his search there. He did not have to look elsewhere, for there, at the bottom of the well, was the child. When he lifted it out it was apparent that the child was dead. The police were called and the body was taken to the mortuary and Susannah Spencer was taken into custody on suspicion of having murdered the child.

This was the outline of the case against Susannah Spencer. After it was related to the magistrates the court was adjourned with Mrs Spencer being remanded into custody to Durham Prison.

On Thursday 17 April 1910, a special court was held in South Shields for the hearing of the charge of murder against Susannah Spencer. The magistrates were Mr John Redhead and Ald J. Grant. The Chief Constable (Mr W. Scott) prosecuted and Mr A. Hall represented the accused woman.

The prisoner was brought from Durham in the charge of two police matrons, who sat with her in the dock while evidence was being given. Mrs Spencer did not seem as distressed as she had been on the prior court hearing. She looked around the court in a rather vacant way as evidence was given. She seemed to pay little attention to the proceedings. While a neighbour was giving evidence she suddenly appeared to follow what was being said. She swooned and her head fell listlessly on the shoulder of one of the police matrons who sat next to her. After being given a drink of water she recovered, saying, 'Oh, dear me.'

When Mrs Spencer's daughter, Margaret, stepped into the witness box to give her evidence Mrs Spencer gazed fixedly at her daughter and muttered, 'That's my bairn.' Margaret glanced at her mother and began to cry. After she had composed herself, she gave her evidence as to what happened on the morning of the tragedy. She then told the court that her mother suffered from pains in the head. At this point Mrs Spencer pleaded with her daughter, 'Speak the truth for your mother's sake.'

The evidence given at the earlier hearing was reported, about Mr Daniel Brown investigating after hearing screams and finding Susannah Spencer attired in her night clothes, soaking wet, standing in the well, and the discovery of the baby's body.

A friend of the family, Hannah Dunlop, gave further evidence. She told the court that when Susannah was about sixteen years of age, she had become ill, and was attended to for about three months by Dr Drummond. After this she was admitted to the Sedgefield Asylum, where she had remained for some months. Before this period she had been a normal, bright girl. After finally leaving the asylum, Susannah returned home, where she remained until she married Mr Spencer.

Dr Sutherland gave his findings on Mrs Spencer. He said that she was suffering from delusions, and on the day after the tragedy she appeared to have no knowledge whatsoever as to what had taken place.

Throughout the hearing Susannah Spencer sat the whole time in the dock, frequently being given water. She made the occasional incoherent mutter and at times began to cry, being comforted by the wardens. As the case went on she seemed to understand the gravity of the situation more, and in places looked to be eagerly following the evidence. 'Oh, Lord Jesus, have mercy upon me', she had cried in an undertone at one stage. On being formally charged by the Clerk of the Court (Mr R. Purvis) she simply shook her head.

The Chairman (Mr John Redhead) committed Susannah Spencer to trial on a charge of murder. He spoke to Mrs Spencer in a very sympathetic way. 'My colleagues and I sympathise with you very much. We sympathise with you and your parents and also your children, but we have a duty here and that is to send you back to Durham to go for trial. We hope you will come out all right. Myself, I think you have not been responsible for your actions.'

Mr Hall appearing for Mrs Spencer, applied to the magistrates for legal aid. He felt that the woman should have legal assistance at her trial. He was applying for legal aid as her husband was at sea and her relatives were in poor circumstances. The magistrates exercised their powers and granted legal aid under the Poor Prisoners Act.

Typical back yards before the Second World War. Washhouses and rainwater barrels were a common sight in yards such as these.

Friday, 25 June 1910, at the Durham County Assizes, the case of Susannah Spencer came before the courts. Mr H. S. Mundahl prosecuted and Mr R. H. Chapman, on the instructions of Messrs T. D. Marshall and Hall, of South Shields, defended.

Mr Mundahl immediately raised the question of the prisoner's ability to plead. He suggested that the prison surgeon be called first, who would give evidence as to the state of the prisoner's mind. The judge made no objection and addressed the jury accordingly. He told them that the history to the case was a very sad one. That the woman had thrown herself and her child down a well, she was got out but tragically the child had drowned before being removed. The question that would be put forward to them now, was not the question of the woman's guilt, but the question of her ability to plead, and if they thought not then they must bring a verdict accordingly.

Dr Gilbert, the prison surgeon, was then called. He said that the prisoner had been in his care at the prison hospital since 31 March, a period of nearly three months. During that time he had kept her under observation. In his professional opinion, the prisoner was not fit to plead and would be unable to understand the proceedings and evidence of the court. Due to this she would also be incapable of giving proper instruction for her defence.

The Judge, owing to this evidence, felt that it would be unfair to put Mrs Spencer on trial. He said it was obvious that she was not fit to plead and advised the jury accordingly.

The jury gave their verdict that the prisoner was unfit to plead. The Judge then ordered that Susannah Spencer should be detained in custody until His Majesty's pleasure is known.

WHO DONE IT

APRIL 1911

On Wednesday, 5 April 1911, the Coroner, Mr A. T. Shepherd, opened an inquest at the Harton Workhouse, into the death of Mr Newbourne Oliver aged 54 of 82 Dock Street, South Shields. His son also named Newbourne Oliver, a seaman, living at Randolph Street, Sunderland, was under remand on suspicion of having caused his father's death.

Catherine Oliver, the deceased's wife, said that her husband had worked as an 'odd man' trimmer. She then went on to give evidence surrounding the events that led up to her husband's death.

On Saturday afternoon, 1 April, her son and her niece, Ida Wiseman, called at her home for a visit. Her son, Newbourne, was keeping company (dating) with her niece Ida, and usually stayed with his uncle, Miss Wiseman's father, at Randolph Street, when he was ashore on leave from his ship.

Catherine Oliver was alone at home when they called, and after a short while they all went to visit her married daughter, who lived in the same street. Newbourne had made enquiries about his father's whereabouts and was told that he was more than likely at the Burton's House bar in Slake Terrace. He went there accompanied by his mother where he found his father having a drink. Mrs Oliver had a glass of beer with her husband and son then returned to her daughter's house, leaving the two men drinking together. The two men arrived at the daughter's house about an hour later. After they had all had tea together, the father and son went out, the father to return to the Burton's House bar to see about a dog and the son to go 'down street'.

Mrs Oliver then returned to her own home alone.

At about half past nine in the evening the husband came home very drunk. He had a rat wrapped in paper, which he said the dog had killed. He had been home for about an hour when his son came in. Newbourne Oliver asked his dad if he wanted to go to Burton's House bar for a drink. His father said that he would like a drink but did not want to go out again. Mrs Oliver went, accompanied by her son, to the public house with a can to fetch a pint of beer to drink at home. On their return, Mr Oliver, who was sitting on a cracket (a form of stool), began a sociable conversation with the son, while Mrs Oliver poured out two glasses of beer for the two men. During the conversation she heard her husband say to her son, 'You're a dirty pig, Newbourne.' When asked by the coroner what had led to this remark, Mrs Oliver said that the remark came unexpectedly as the conversation was not of an unfriendly nature, and she expected that it came about because her husband was drunk.

Going on with her evidence, Mrs Oliver said that after the remark had been made, her son went across to his father and grabbed hold of him by his muffler and shirt and said, 'Do

Mr Victor Grunhut, solicitor for the defence of Newbourne Oliver. This photograph was taken in 1916 when he was a Major in the Royal Artillery.

you know the language you are using in front of my mother?' He shook his father and then let go. Mr Oliver then jumped up from the cracket and grabbed his son at the throat by the collar but the son put his father back on the cracket. Mr Oliver then got up again and went to the closet to get a knife with which to cut some tobacco, while he was in the closet he fell to the floor. His son lifted him up and again placed him on the cracket, at which point the son left the house. Mrs Oliver left the house about fifteen minutes after her son to go to the shops across the street. On returning home she found her husband lying beside the kitchen door bleeding from the back of the head.

Mrs Oliver went to her daughter's to get help. On her way there she met her niece, Ida Wiseman, who was on her way to Mrs Oliver's to meet Newbourne. Mrs Oliver told Ida that Newbourne had gone and that she, Ida, had better get him away to Sunderland as he had had a row with his father and she was afraid he might return and there would be more trouble. Mrs Oliver returned home with her daughter. Mr Oliver was conscious and swearing as his wife and daughter bathed his head. Mrs Oliver remained with her husband all night. For most of the night Mr Oliver was 'rambling and talking'. At about ten thirty on the Sunday morning Mrs Oliver sent for Dr Turner. The doctor put two stitches in a wound on Mr Oliver's chin and told Mrs Oliver that he suspected that her husband had taken a slight stroke and advised his removal to the hospital.

Mrs Oliver's daughter went to Sunderland to tell her brother Newbourne of the morning's events and Newbourne returned on the afternoon to his mother's home. Newbourne did not discuss the events of the previous evening but went to see the doctor.

On the Sunday evening Mr Oliver was taken, unconscious, to the Workhouse Hospital where he remained unconscious until he died on the Monday night, 3 April.

When questioned by the Coroner Mrs Oliver stated that she had bathed her husband's head on the Saturday night and had noticed blood on his chin but did not think it was a severe wound but just a scrape. She also stated that her husband had been drinking all week. At this point, after Mrs Oliver had given her evidence, the Coroner adjourned the hearing.

At the resumed inquest on Monday, 10 April Mrs Oliver's daughter, Mary Elizabeth Varlack, gave her evidence. She gave her address as 16 Dock Street and that she was the wife of a rolley labourer.

Her evidence was similar to her mother's as to the family having tea together at her house and her father and brother leaving her home, the father going for a drink and her brother going down street. Her brother, Newbourne, had returned to her house about 10 pm and had some supper with her and had then gone out to enquire about the times of the trains to Sunderland. He had returned back to her house about 11 o'clock and had told her that he had had a few words with his father about the father using bad talk. Her brother and Miss Wiseman then left to go to the train station to catch the train to Sunderland, she accompanied them.

On their way to the station, Miss Wiseman, on her own, called into Mrs Oliver's home to say goodbye to her aunt and uncle, she caught up with them afterwards. Mrs Varlack left her brother and cousin near to the station and made her way back home. On the way she met her mother who told her about her father's condition. When she arrived at her mother's house she found her father lying behind the kitchen door. He was unconscious and bleeding from the chin. Assistance was called for and Mrs Varlack bathed her father's chin. Her mother went out to seek a policeman but returned without one. Mrs Varlack told the two people who had come to give assistance, a woman neighbour and a young man, that she thought her father was only stupefied with drinking and that she had often seen him in this

An inside view of a public bar in the early 1900s. A far cry from today's wine bars.

state. She said that whilst she bathed her father's chin she had not noticed any other injury. She had then gone home and left her mother and father alone in the house.

The next morning her mother had sent for her. When she got to her mother's she found her father lying on the mat on the kitchen floor where he had been left the night before. Her father was in a semiconscious state. She then went out to get Dr Turner, who came and put two stitches into her father's chin. Dr Turner had said that he thought Mr Oliver had taken a slight stroke and advised his removal to hospital.

Miss Ida Wiseman, giving evidence, corroborated what her cousin, Mrs Varlack, had told the hearing. She also stated that when she had gone into her aunt's home to say good-bye on the Saturday night, she did not see her uncle. Newbourne and herself had caught the last train to Sunderland on the Saturday night. On the Sunday morning, Mrs Varlack had called at her home to tell Newbourne about his father's condition. She had then accompanied Mrs Varlack and Newbourne to Tyne Dock where she had seen her uncle Mr Oliver. He was semi-conscious and knew her, but had said nothing about his injuries.

Ida told the Coroner, when questioned, that Newbourne was perfectly sober on their return home on the Saturday night. When shown the prisoner, Newbourne's, suit of clothes and boots, she confirmed that they were what he was wearing on the Saturday night and that they had been pawned on the Monday.

Jane Meeks, who lived in the flat above Mr & Mrs Oliver, at 84 Dock Street, was called to give evidence. She told that she had heard a row downstairs on the Saturday night. The only voice she could distinguish was that of Mr Oliver. She heard him say, 'you dirty cur. You struck me when I was down. I never done that to you.' After this she heard nothing more, but two or three times during the night she had heard someone moaning.

Thomas Ramsey, aged ten years, who lived at 74 Dock Street, told the court that he had seen a man coming out of the Oliver's back yard about 11.30pm on the Saturday night. He said that he would not recognise the man again nor could he remember how the man was dressed.

The medical officer of the Workhouse, Dr Spence, gave evidence that the deceased was admitted to the Workhouse Hospital on Sunday night and had died the following day. On the Wednesday he had made a post-mortem examination in the presence of other doctors.

Dr Spence described various bruises about the head and face of the deceased. On the chin there was a one and half inch long wound and on the right hand side of the head there were three contused wounds, one two inches long and the other an inch long. Neither extended to the bone. The brain was lacerated.

In reply to questions put by the Coroner, Dr Spence said that the cause of death was fracture to the skull and laceration of the brain. This must have been caused by direct violence by some kind of blunt instrument and could not have been as a result of a fall. On being shown a poker, he said that such an instrument would have caused the wounds. Dr Spence was also shown the clothing of the prisoner, Newbourne Oliver. He said that the stain marks on the jacket sleeve; shirt sleeve and the boots resembled bloodstains.

Dr Sutherland, police surgeon, who was present at the post-mortem, agreed with Dr Spence that all the wounds must have been caused by direct violence, either a violent kick or blow.

Mrs Varlack was recalled and questioned about the blood on her brother's clothing. She said that on the Sunday afternoon, when her brother had come back to their father's house, her father was lying on the floor. Newbourne had raised his father's head to give him a drink of water. She could not remember which arm he had used.

Sergeant Lampshire gave evidence of having met Newbourne Oliver in Talbot Road on the Monday night as Newbourne was on his way to the hospital to see his father. He requested Newbourne to accompany him to the police station where Sgt Lampshire spoke to him about his father's injuries. Newbourne had said, 'That's strange. I shook hands with him before I left to go home to Sunderland. The only thing I saw was that he fell against the couch and struck his head, but there seemed to be nothing wrong with him then.'

Det. Inspector Bruce stated that after hearing about the deceased's death on Monday night, he told Newbourne Oliver that he would be detained on suspicion of having caused his father's death. Newbourne had replied, 'I have got nothing to say. I cannot say anything. 'Suspicion of causing his death, did you say?' Inspector Bruce said, 'Yes,' and Newbourne had then said, 'I don't see where the suspicion comes in. All I can say is that I am heartily sorry he is dead.' Inspector Bruce went on to say that he had searched the house at 84 Dock Street on the Monday night. In the kitchen, behind the door, there was a large stain on the floor, which appeared to be blood. There were also bloodstains on a wooden stool and on the wall of the kitchen closet. In the closet there was a pan and steamer, the rim of the latter was battered as though it had been struck by something, but it did not look recent. Two pokers were also found.

Before the Coroner addressed the jury, Newbourne Oliver was asked if he would like to say anything. He declined to do so. The Coroner then went on to address the jury. He said that there were two suggestions of how the deceased met with his injuries, one that it was an accident the other that it was violence. After hearing the doctor's evidence he felt they would have little difficulty in making their minds up as to which decision to accept. The real difficulty lay in coming to a conclusion as to who was responsible and the evidence on that point was largely circumstantial.

A recent photograph of the Royal Hotel, Hudson Street, Tyne Dock, now derelict This was not far from Newbourne Oliver's address and next to the railway station that his son and niece used when visiting the family.

After an interval of a few minutes the jury announced a verdict of manslaughter against Newbourne Oliver. On hearing this he fell heavily to the floor in a faint. His mother broke out into sobs and wails, while his sister and cousin also appeared ready to faint. Constables rendered assistance to him, and he soon recovered and was then removed to the Central Police Station.

At a special magistrate's court hearing later the same day, Newbourne Oliver was charged with having caused his father's death.

The Chief Constable, Mr William Scott, outlined the details of the case as described at the inquest. Mr. Scott said that in fairness to Newbourne Oliver, he should state that the deceased was of a quarrelsome disposition, and frequently fought with his family as if they were men.

Evidence given at the inquest was repeated, with Mrs Oliver adding that her husband was a very violent man and on one occasion she had been separated from him. During all her married life her husband had been addicted to drink and violence. Her sons and daughters had been practically driven from home owing to the violence. Her son had always been a good son to her, and had done a good deal for the family. He had been frequently badly assaulted by his father.

The magistrates, after hearing all the evidence, considered a prima-facie case had been made out and it was their duty to commit the prisoner for trial.

Mr Victor Grunhut, solicitor for the defence, applied for bail. He said that Newbourne Oliver had always done his best for his father and mother and the rest of the family, and it was the irony of things that he should have to go to the Assizes to stand trial on a charge of this kind. He went on to say that he thought that even if the prisoner were found guilty only a slight punishment would be imposed. Newbourne Oliver was the only support of his mother, and had been so for a very long time.

The magistrates granted bail in the sum of £120, £60 in prisoner's own recognisance and two sureties of £30 each, or one of £60.

At Durham Assizes, 5 July 1911, the jury returned a verdict of not guilty and Newbourne Oliver was discharged. Whoever caused the death of his father remains a mystery.

A SHILLING FOR THE WIFE

NOVEMBER 1913

On Monday, 24 November 1913, an inquest was held into the death of George William Dockerty, aged 29, a foreman boiler cleaner of H. S. Edwards Street, South Shields. His wife, Mary Dockerty aged 27, was in police custody on a charge of having murdered her husband.

The couple had been married for nine years and lived with their only child, a boy, in a downstairs flat at the above address. Mr and Mrs James McAndrews, the parents of Mrs Dockerty, occupied the flat. The flat consisted of three rooms' front room, small bedroom and kitchen. Mr and Mrs Dockerty, with their son, had the small bedroom and shared the kitchen with the wife's parents.

Mrs McAndrews, Mrs Dockerty's mother, gave the following evidence. She stated that she was the wife of James McAndrews, a driller, and they lived at H.S. Edwards Street. The prisoner in custody was her daughter, Mary, and the deceased man was her son-in-law. He had married her daughter on 18 August, nine years before.

The deceased and his wife had lived in various houses during their married life. They were both in the habit of taking too much drink. On two occasions her daughter had obtained separation orders against her husband, but they had on each occasion gone back to live together. There had been two children of the marriage, but only one had lived, Charles, who was seven years old.

About four months before they went into a two roomed flat in Havelock Street, but the house was broken up owing to a quarrel, and the deceased man came to stay with her (witness). At that time the boy, Charles, was staying with her. About a week later the prisoner, my daughter, came and asked to be taken into the house as well. She went on to say: 'my son-in-law paid me 15s a week for their keep and paid his wife pocket money. During the time that they stayed with me they used to argue most of the time, mainly at the weekends. The quarrels were mainly to do with drink and jealousy. On Saturday morning about half past eleven the deceased went to go out to draw his pay. My daughter said that she hoped he would not be long in coming back and that she wanted to know what pocket money she was going to get. He said he did not know what he would give her until he came back from the office. Before he went for his money he told her he did not think he could give her anything, as she had not worked for it. It was about a quarter to twelve when he returned.'

He paid her (witness) 11s 6d, and he offered his wife a shilling. She threw it back at him saying she would not have it. Although his dinner was ready he went straight back to work. He returned about half past four and had his dinner then.

'Was anything said then?' asked the Coroner.

'There were a few words, but I did not pay much attention to them.'

'What was it about?'

'The old subject, about money.'

Pressed by the Coroner, the witness said the man said something about his wife always 'chewing the fat' – at breakfast, dinner and tea.

Returning to the shilling incident, the Coroner asked the witness to try and remember what precisely took place. The witness said her daughter threw the shilling at her husband, refusing to take it, and she said he would give a prostitute more than he offered her. She said she wanted more money.

'Did she say anything about she was going to have it?'

'No. I do not think so.'

After having his meal the deceased had a wash and went out. The prisoner went out shortly afterwards, and then she (witness) went to do some shopping. The witness got back about five o'clock. The prisoner, deceased, and witness's husband were having tea in the kitchen. The prisoner and deceased seemed to be all right again and no 'words' were passed.

The deceased washed himself again and went out about seven o'clock. The prisoner went out shortly afterwards and came back about quarter to nine.

'What was her condition?' asked the Coroner.

'She appeared to have had a little drink.'

'What do you call a little?'

'Well, she was not drunk and she was not sober.'

After that the witness went out and returned at 10.45pm. The prisoner was then in bed and the deceased was in the house. The witness had occasion to go out again to do some shopping, and did not get back till 11.30pm.

Her husband and the deceased man were in the kitchen, and the prisoner was still in bed. The deceased was in his shirt sleeves. He had apparently been in the bedroom and hung up his jacket and vest behind the door. He had had a good deal of drink. He had his supper and then went into the bedroom. While he was in the kitchen his wife shouted from the bedroom to him, 'Why are you so late coming in, where have you been?' He had not been in the bedroom very long before her daughter shouted, 'Mother! Mother!'

'I asked her what she was shouting out like that for at that time of night,' said the witness, and she shouted again, 'Come here, he has knocked the half of my face off with a shoe.'

'I went into the bedroom,' continued the witness. 'My daughter was sitting up in bed and her face was covered with blood. It was cut and it was bleeding so profusely. She said that he had thrown the shoe at her and it hit her on the face. The deceased was standing between the foot of the bed and the dressing table. He said it was nothing and to wipe the blood off.'

The witness came into the kitchen and the deceased either just before or just afterwards also came out of the bedroom. The witness sat on a chair near to the bedroom door and the deceased brushed past her and went back into the bedroom. He was only a few minutes there when he came rushing out again holding his right breast and shouting, 'I am stabbed, send for a doctor.' His shirtfront was open and blood was running down his chest. He was holding his breast with both hands and was shouting for a dish of water. She met her husband coming in with a dish of cold water as she went out for the doctor.

She went for Dr Hodgkinson in Laygate Lane, and he came at once, following her down to the house. When she returned the deceased was lying on his back on the kitchen floor. He appeared to be dead. Her husband, the prisoner, and two neighbours were in the house. Then the doctor came, and he was followed by a constable and by other constables. She

(witness) was in a state of collapse at the time, but as far as she could remember the doctor examined the deceased and pronounced 'life extinct'.

In reply to the Coroner she said the prisoner did not follow her husband out when he came into the kitchen shouting, 'I am stabbed.' She did not see her daughter up to the time of going for a doctor. The deceased man did not say his wife had stabbed him. He did not mention her name.

The witness then described a pathetic scene, which took place over the deceased man's body. 'When I came back,' she said, 'the prisoner was bending over the deceased man and making a lament and calling of him by name. She couldn't realise he was dead. I can't repeat the exact words she said, but she was talking to him and asking him to speak to her. She didn't believe he was dead, and called again and again for him to speak to her.'

'Are you sure of that?' enquired the Coroner.

Witness (who was greatly moved), 'Aye, quite sure of it.'

Asked who was the worst for drink between the prisoner and the deceased, the witness answered, 'the deceased was much the worst at that time.'

The prisoner was able to walk all right. She did not see a knife that night. The police officer found one the next morning. The pocket-knife produced belonged to the deceased she thought. He only bought it on Wednesday and she had seen him cutting tobacco with it. At this point the inquest was adjourned for a week. Shortly after the adjournment of the inquest Mrs Dockerty was brought before the magistrates in the adjoining court on the charge of having murdered her husband by stabbing him with some sharp instrument. The court was filled with spectators, and the magistrates on the bench were Dr Legat (in the chair) and Alderman G. T. Grey.

The accused woman's bearing in the dock was one of apparent composure. She had no hat on of any kind and over her shoulders she wore a grey woollen shawl. On the Clerk (Mr R. Purvis) reading out the charge, solicitor, Mr H. Jacks, intimated that he appeared for the prisoner. The Chief Constable said he proposed to offer only sufficient evidence to justify a remand. He then went on to relate the events that had happened in the early hours of Sunday morning. He stated that when he arrested Mrs Dockerty she had said, 'He must have had the instrument and done it himself, I am not guilty. He flung a boot at me and I came out of the room in my chemise.'

Mrs Dockerty was remanded in custody and was sent to Durham gaol where she would be detained until the resumed inquest and police court proceedings. Simultaneously with the magisterial proceedings on 3 December, the Deputy Coroner held the resumed inquest in the adjoining court. The evidence given was practically the same in both courts with the jury returning with a verdict of wilful murder, under extreme provocation, against the prisoner. The prisoner, although looking a little pale, was perfectly placid, and listened quietly and attentively to the evidence that was called. At the request of her solicitor, Mr Winskell, she was accommodated with a chair.

Mrs McAndrews, the prisoner's mother, was then called and repeated the statement she made before the Coroner. Mr Winskell examined the mother.

'Was the deceased a violent man?' he asked.

Witness: 'Yes, very passionate.'

'Do you know that he broke her jaw on one occasion?'

'Yes.'

'Did Mr Hodgkinson attend to her then?'

'Yes.'

The Commercial Hotel not far from where the Dockerty's lived. Right next to the docks, it has survived the area's redevelopment and stays much the same as it originally was.

'Did the deceased man put his wife's shoulder out on another occasion?'

'Yes, he did.'

'Did Inspector Armstrong come to the house at that time?'

'Yes, I believe so, but I was not there.'

'On the night before the tragedy was the deceased very drunk?'

'Yes.

'Did he have the DTs?'

'I think so, he did not know where he was.'

'He was up in his own bedroom the whole night. She took his breakfast to the door, but did not see him.'

After the boot incident the deceased man was not more than two minutes out of the bedroom before he returned. He simply walked to the fireplace and returned.

'Could your daughter have got out of the bed without him hearing her?'

'Oh, no.'

'When he came into the kitchen he said, "I am stabbed," without mentioning his wife's name?'

'Yes.'

'He did not say, "I have been stabbed," or mention his wife's name at all?'

'No.'

She was in the room all the time the policemen were there, and she never heard her daughter say 'Oh, what made me do this?'

'Has the prisoner ever threatened to do away with the deceased?'

'Not in my hearing.'

'Has the deceased threatened to do away with the prisoner?'

'He has often said he would do for her.'

Dr C. J. Sutherland stated that at the request of the Coroner he was present at a

post-mortem examination of the deceased man on 25 November. The only external injury was a deep gaping wound in the neck about half an inch above the collarbone and one and a quarter inches in length. Some sharp pointed weapon such as the knife produced could have caused the wound. Death was due to loss of blood, which had been very great and rapid. The heart was absolutely devoid of blood. All the other organs were normal.

In reply to the Chief Constable, the doctor said he did not find any evidence that the deceased had been given to excessive drinking, but he was a young man and it was possible that he might be an excessive drinker and that the organs of his body might not show any signs of it.

Mr Winskell: 'Supposing the wound to have been caused by this knife, would it have needed much strength to cause it?'

Dr Sutherland: 'Not a great deal. There were no dense tissue to cut through.'

Mr Winskell: 'Considering the nature of the wound, could it have been self inflicted?'

Dr Sutherland: 'It could not.'

Mr Winskell: 'If the wound was inflicted by any other person which hand would have been used?'

Dr Sutherland: 'Either might have been used, but probably the right one.'

Indicating by signs of a struggle in which the deceased and the prisoner had been pushing each other with their hands, Mr Winskell asked whether the knife might have been accidentally driven into the deceased's neck in the course of the struggle and Dr Sutherland replied that he did not think so.

PC Henry Owen gave evidence of having been called to the house shortly after midnight and found the deceased's body lying in a pool of blood. The prisoner threw herself down beside the body, and cried and said, 'Oh, dear, what made me do it?' She was flinging her arms up and pulling her hair. PC Owen had searched the house but found no weapon. He arrested Mrs Dockerty and took her to Laygate Police Station. Inspector Armstrong stated that on searching the house he discovered a cut in the flock bed. On looking inside the cut there was discovered an open knife. The knife was now in court as evidence.

After all the evidence was heard the Chairman said the Bench was satisfied that there was a prima facie case, and that the prisoner should be committed for trial.

Mr Winskell said that in a murder charge there must be evidence of malice aforethought, and he submitted that up to this present time no evidence of that kind had been adduced.

The Clerk said that was a matter for the jury at the Assizes. Mr Winskell said that there was no reason for murder, however, if the Bench had decided that there was a prima facie case then he wished to apply for legal aid under the Poor Prisoner's Defence Act. The magistrates granted the application.

On being formally charged and asked if she had anything to say, Mrs Dockerty firmly replied: 'Nothing. Just that I am not guilty of causing his death.'

At Durham Assizes, 4 March 1913, the Judge directed the jury to a charge of manslaughter. The jury returned a verdict of manslaughter under great provocation and with a recommendation to mercy.

Mary Dockerty was sentenced to three months hard labour.

BATTERED TO DEATH

NOVEMBER 1917

Emily Thompson, a widow, aged 39, lived with her family at 387 South Palmerston Street, South Shields. Her husband, Stoker Thompson, who had worked, as a checker at the Tyne Dock yard had died some time before.

Emily Thompson was known in the neighbourhood as a very peaceable woman and not a woman to have a quarrel with anyone. Her nights were spent mostly looking after Mr Charles Archibald's children. Mr Archibald was a widower with three children. Emily Thompson had known Mr Archibald for a number of years. At one time, while he was at sea, Mrs Thompson had looked after his two daughters who were ill at the time. On his return from sea Mr Archibald obtained a job ashore as a labourer and from that time Emily Thompson had looked after his children when he was at work, after they came home from school. Charles Archibald lived with his family in Francis Street, South Shields; this was just a five-minute walk away from South Palmerston Street so the arrangement worked quite well. Mrs Thompson usually stayed at Francis Street until about 10 o'clock at night, or she left earlier if her work was finished. When Mr Archibald worked nights then Emily Thompson would stay overnight. Mr Archibald found Emily Thompson to be a very hard-working woman, and as far as he knew a respectable woman, he did not know of anyone who held a grudge against her or was on unfriendly terms with her. She said very little at anytime to him and did not talk about her friends.

Emily Thompson was in generally good health apart from suffering from severe neuralgia, which she had been suffering from for a long time. She had been attended to by Dr McHaffle and had last seen him on 26 November when she had had six teeth extracted. This did not stop her from attending to her work at Francis Street.

On the Wednesday evening, 28 November, at 5.30pm she was at her home talking to her son, Albert Thompson, a miner at Harton Colliery. She was asking him how he was getting on with his work. At 6pm Albert left the house saying good-bye to his mother, not knowing that this was the last time that he would see her alive. He arrived back home at 7.30pm the same evening and went to bed at 8.15pm. His mother, as usual, he thought, would be at Francis Street and was not really expected back at this time, and if Mr Archibald was working nights then she would not be expected back until the morning. On this Wednesday night, Albert did not know if his mother intended to stay the night at Francis Street. On Thursday morning he was informed that his mother had died in the Ingham. Infirmary.

Emily Thompson had gone to Francis Street the night before. She was there with one of her daughters when Charles Archibald returned home from work at 8.30pm. Her daughter left at about 9 o'clock, Mr Archibald had heard Emily Thompson tell her daughter to tell Hilda (her other daughter, who was at home) to leave the back door open, as she would not

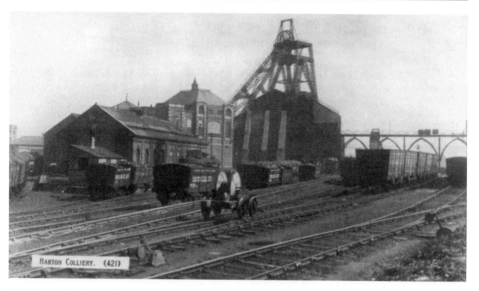

The Harton Colliery where Emily Thompson's son Albert worked

be long in being done with her work. Emily Thompson had then stayed until 10pm and then left for her home. She left by the front door, closing the door herself. Nobody went to the door with her. Charles Archibald was in the kitchen in front of the fire at the time. He noticed nothing unusual about Emily when she went away. She had been pleasant with the children and cheerful. As was usual she called out 'Goodnight.' She never stopped later than 10pm, and some nights she went away earlier – just as she finished her work, apart from the nights she stayed over. Mr Archibald stated at a later date, that he never saw anyone leave the home with her or meet her. When he was asked if Emily Thompson was likely to go into a back lane with a stranger, he replied that she would not do such a thing, she was not that sort of woman. He only knew her to be a respectable woman and also that she was tee total.

On Thursday morning at about 7.30am, Emily Thompson's daughter arrived home just after finishing work cleaning offices at Tyne Dock. She had left home early to go to work and usually returned about 7 o'clock, except for one morning a week when she did certain extra work, which made her an hour later. When she had arrived home on the Thursday morning she found her mother missing and things in the house just as they were when her mother left the night before. The daughter thought that her mother, for some reason, had spent the night at Charles Archibald's house, maybe he had to go back to work. She then called on their neighbour, Mary Ann Fairs, wife of Thomas Fairs, a sea-going stoker, at 385 South Palmerston Street. She had called on Mrs Fairs because she knew her mother often called in for a cup of tea early in the morning on her return from Francis Street. Mary Ann Fairs had not seen Emily Thompson that morning.

On the previous night, at the time that Emily Thompson should have been safe and secure in her own home, Thomas Colby, a coal miner of 572 John Williamson Street, was on his way home at about ten past eleven. He was walking by way of South Frederick Street and then went through the back of Trevelyan Terrace, which is at the end of John Williamson Street and South Frederick Street. On the Frederick Street side, about six or seven yards from the end of the street, he saw something lying on the ground. He saw that it was a woman, but did not know if she

was drunk or asleep. This was close to the back door of his house so he went inside to get some matches. When he returned and struck a match to see by, he fully realised that the woman was very severely injured. She was lying in a huddled up position, partially on her side. Her face looked battered and bruised and her head was lying in a pool of blood. Emily Thompson was just 200 yards from the house in Francis Street. This was no accident; so he thought he'd better get a policeman quick. In nearby South Eldon Street he found Sergeant Witty and PC Scott and reported the matter to them. They quickly returned with him to the spot where the woman was still lying in the same position. On examination it was found that the woman was still alive but unconscious and frothing at the mouth. Thomas Colby was asked if he knew who the woman was, he said that he had never seen her before in his life. Sergeant Witty made arrangements for the removal of the woman by hand ambulance to the Tyne Dock Police Station. At the police station, Sergeant Witty, on examination, found a contused wound on the right hand side of the woman's head, behind the right ear. Both of her eyes were swollen and discoloured and she had been bleeding from the nose, the woman was still unconscious. He dressed the wound on the head and sent for Dr Sutherland. When the doctor arrived he also examined the still unconscious woman and immediately ordered her to be taken to the Ingham Infirmary. He accompanied the unconscious woman there where he communicated to Dr Montgomery what little information he had and the details surrounding the finding of the woman. Emily Thompson died at three o'clock on the morning of 29 November. She never regained consciousness.

Dr Montgomery, house surgeon at the Ingham Infirmary performed an autopsy on Emily Thompson's body. When the clothing was searched they found a penny, a metal brooch, three keys and a North Eastern Railways employee's disc, No 472. The examination of the body revealed that she had bled from the nose; both eyes were swollen and discoloured. On the right side of the head there was an irregular star shaped lacerated wound covering an area of the scalp of five inches, and penetrating to the bone. There were also five wounds on the right side of the head, varying from a half inch to three and a half inches in length, extending down to the bone. There was a fracture to the skull two and a half inches long, which must have been caused by a blunt instrument used with considerable force. He was of the opinion that death was caused by shock following a fracture of the skull and haemorrhage.

The police had made a search of the area where Emily Thompson was found. In the same vicinity there was found, in a gully, a piece of metal, evidently part of an old bicycle frame. This may have been the murder weapon. Chief Constable, Mr Williarn Scott, enquired at other police forces to see if any similar offence had been committed in their area, or if they had any person in custody charged with a similar offence or if they had any suspicions of any persons capable of carrying out such an offence. These enquiries proved fruitless.

The Coroner, at the inquest into the death of Emily Thompson, said that the post-mortem had made it very clear what had caused the death of Mrs Thompson. That death was the result of foul play by some person or persons unknown. The police had made exhaustive enquiries, without, up to the present, are able to find any clue. He did not think it would serve any purpose in adjourning the inquest. He pointed out that this did not mean that the police would relax in their efforts in the matter, and that if an arrest should be made the law would take its course in the usual way.

The jury returned with a verdict of 'Wilful murder against some person or persons unknown.'

The mystery of who killed Emily Thompson and the reason why, must, for this book, remain a mystery. During my research I could find no solution to this murder and no motive behind it.

BROTHERLY LOVE

FEBRUARY 1919

Faid Abdula, an Arab, had lived in South Shields for some considerable time and had run a business on a fairly extensive scale as a refreshment and boarding house proprietor. His business was situated in Thrift Street, where at No 4 he ran a boarding house, and at No 63 he ran a boarding house and refreshment house combined. These premises catered exclusively to his fellow countrymen. No 4 Thrift Street was for boarders only and had no catering facilities, so the boarders would go to No 63, which was just across the narrow road and right opposite to No 4, to have their meals with the other boarders. Faid Abdula's brother, Nassar Abdula, assisted with the managing of No 63 for his brother Faid, an arrangement of long standing.

Faid Abdula lived at 4 Thrift Street with his nineteen-year-old English wife who he had married the previous year and their son who was just a few months old. His wife also assisted in running the business. His brother, Nassar, lived on the premises at 63 Thrift Street.

On the morning of February 1919, Faid Abdula had been to Sunderland to arrange for the hiring of an Arab crew to work on board a ship. Besides running a boarding house and refreshment house, Faid Abdula would also act as an agent for Arab seamen to find them work on board ships. This was a common practice amongst the Arab boarding house keepers. On his return, Faid and his wife went about their duties in the refreshment house. They each took turns at looking after their son in the room that they occupied across the road at 4 Thrift Street. Mrs Abdula had returned from one of her visits to her son and had asked her husband to go across and see to the child who had been crying. She never saw her husband alive again.

About ten minutes after Abdula went into No 4 to see to his son, shortly before 7pm an Arab boarder, Mr Warhub, who had been sitting in No 63, went across the road and entered No 4. Upon going to his room he passed Abdula's room, glancing in he saw Faid Abdula lying on the floor in a pool of blood. He at once rushed outside and informed the police. The first policeman to arrive was PC Flegg; he was joined shortly after by the Chief Constable William Scott, Supt T. G. Young, Chief Inspector Bruce and PC Goodwin. After they confirmed that Faid Abdula was dead they began to make a thorough examination for clues at the scene in the hope of discovering some clue as to the perpetrator of the murder. Faid Abdula had been clubbed, strangled and knifed to death.

It seemed evident that robbery was the motive for the crime from the fact that the safe in the room was open and papers were scattered about the floor. Near to the safe was a bunch of keys, including the key to the safe. The murder had only taken place a short while before, as the body of the dead man was still warm. Dr Sutherland, the police surgeon, was

46

called to the scene and he examined the body. In his opinion the injuries which caused the death, were a heavy blow to the back of the head from a blunt instrument. There was a wound on the left temple inflicted with a knife and there was a stab wound on the upper part of the chin that had penetrated through the lip into the mouth. There was a muffler tied tightly around the neck. The end of one of the dead man's fingers was almost severed, and this injury, coupled with the fact that the room was in some disorder, lends support for the theory that a fierce struggle had taken place.

The police, after searching the room, found no weapon that could have been used to cause the death of Mr Abdula, nor could they find any clues as to who had carried out the deed. They suspected that someone who knew the deceased very well and was acquainted with Mr Abdula's movements was responsible. The keys to the safe were found on the floor, so it seemed possible that Mr Abdula had either opened the safe or was about to do so when he was surprised and attacked.

When questioned, Mrs Abdula stated that she had left 4 Thrift Street to go across the road to No 63 to work in the refreshment rooms, she had asked her husband to go across the street to see to the child, who had been crying. She heard and saw nothing concerning her husband until the Arab boarder, Mr Warhub, came running across the street to inform her of the discovery of her husband's body. She had run across to the room they occupied on the first floor immediately facing the refreshment house. Her husband was lying on the floor apparently dead and the little child was screaming, whereupon she removed it to another part of the house. She was asked if she recognised the muffler that was tied tightly around her husband's neck and she said that her husband was not wearing the muffler when he had left the refreshment house and that it did not belong to him, but that she had seen it previously in the boarding house. Mrs Abdula confirmed that money and jewellery had been stolen. The money consisted of £150 in £5 notes, £150 in gold and £130 in £1 notes and 10s treasury notes. Apart from the jewellery in the safe, her husband's rings and jewellery were missing from his body. The total amount would come to well over £600. She also stated that there was a revolver in the safe earlier in the day, which was now missing.

Nasser Faid, the dead man's brother, who was present, was asked if he had any evidence to give. He stated that he was sitting reading a newspaper at 63 Thrift Street when his brother went over to No. 4 to see to the baby, he then said that Mrs Abdula had followed her husband over and came back shortly afterwards. Mrs Abdula denied following her husband back to No. 4 whereupon Nassar Faid said that he had made a mistake. A piece of hair that was found on the body was shown to Nassar and he was asked if he knew to whom it belonged. He replied, 'Me know, me know,' and he then named a man who had accompanied Faid Abdula to Sunderland that morning. He then repeatedly said that the man who killed his brother had took watch, chain, money, cheque-books and revolver. 'All gone,' he said.

Dr Sutherland was of the opinion that the missing revolver was the likely weapon that caused the wound to the back of the head. He later confirmed, after a post-mortem, that while the blow to the skull was sufficient to cause death, it was in fact the stab wounds that were inflicted by a dagger that was the actual cause of death, being a sharp double-edged weapon.

This murder took place in 1919, and at this time there was a lot of prejudice in the town against the Arabs and other coloured people. This prejudice not only existed amongst the working class population, but also extended to Aldermen, the courts and possibly the police themselves. This may explain the conclusions and actions taken by the Chief Constable (Mr William Scott) on the discovery that the murder weapon was a double-edged dagger. Suspicions

were narrowed down to Arabs and coloured men who were thought to have a common practice to carry this kind of weapon. The Chief Constable circulated information about the murder among police forces throughout the country. He suggested that special enquiries should be made among Arabs and other coloured men, also at banks, moneylenders and gold buyers.

On the 22 February, Nassar Faid went and told the police that he suspected his brother's insurance agent, Michael James Kinlin, of committing the crime. Kinlin was an ex-inspector of police and was now an insurance agent for the Co-operative Society. When questioned by the police Mr. Kinlin denied any knowledge of the crime. He said that he had known Faid Abdula for nearly two years and had last seen him about 4 o'clock on 18 February at 63 Thrift Street, and they both went across to No 4 where Faid Abdula had paid him a premium of 5s. He had stayed talking to Faid Abdula for about eight minutes and then left about ten past 4. He gave an account of his movements after this showing that he was not near No 4 again that day.

Kinlin was easily eliminated from police enquiries, as was also the Arab who had accompanied Faid Abdula to Sunderland on the morning of the day of the crime. By this time the police were having suspicions about Nassar Abdula which led to Chief Constable Scott and Chief Inspector Bruce along with Det Sgt Wilson going to the premises of 63 Thrift Street on 25 February to interview Nasser Abdula and to search his room.

The Chief Constable asked Nassar Abdul to show him where he slept in the boarding house. Nassar took him to a room on the ground floor and pointed to a bed, he told the Chief Constable that this was the bed he had slept in the previous night. When asked if this was the room that he normally slept in, Nassar admitted that he only occasionally slept in the room and upon the Chief Constable's insistence he led them to a room on the first floor where he usually slept and lived. Nassar was then told that this room was going to be searched. 'You search everybody like this?' Nassar asked. He was told that the police search everybody who is suspected of being connected with any crime. A trunk was found inside the room that Nassar admitted was his property. When the trunk was opened, inside was a large number of £5 and £1 bank notes scattered, some crumpled up like scraps of paper. There was nothing to indicate to whom the notes belonged. Nassar Abdula was asked how much money in total was in the box. He could not say. At this point Nassar seemed to sway and looked as if he was going to faint. He was advised to sit down for a while until he recovered his senses. Upon recovery he was told to stand up while Sergeant Wilson searched him. In Nassar's pocket and about his person there were found bank notes, a watch, rings and three cheque books, some of which had been used. Also found upon Nassar was a fully loaded revolver. The watch that was found had belonged to Nassar's dead brother and was the watch that he was wearing on the night he was murdered, and which was missing. The police knew this because Nassar himself had given them a description of the missing watch on the night of the murder and had also given a description of the missing cheque books. Nassar insisted that the watch was his and also the other articles.

Mrs Abdula was sent for to see if she could identify the possessions that were found in Nassar's trunk and about his person. When Mrs Abdula came, Nassar was again asked if the watch belonged to him, he replied yes. The watch was then shown to Mrs Abdula, who identified it as the one belonging to her husband. Nassar Abdula then stated that he had found it in his brother's safe. Mrs Abdula replied: 'No, Nassar, you cannot say that. It was not in the safe. It was kept in a drawer on top of the safe.' She identified the watch by a scratch on the face, which she said had been made by a diamond ring. She then identified two crossed cheques, which she said had been in the safe on the night of her husband's murder.

The Chief Constable told Nassar that he must consider himself in custody and that he would be charged with the wilful murder of his brother. When cautioned, Nassar said: 'Me be easy. Me be easy,' Which he afterwards kept repeating. After arresting Nassar, the Chief Constable carried out a further search of Nassar's room where he found some boxes and each of these boxes also contained money.

At the Magistrates Court in South Shields, Mr Grunhut appeared for the defence of Nassar Abdula. At the opening of the court, Mr Grunhut spoke about the money found in Nassar's possession. He said that there was approximately £1,000 found that was now being held by the police. The position regarding money was a very difficult one as the deceased man had, in his will, made his brother, Nassar Abdula, his universal legatee and sole trustee. Also the prisoner had a considerable amount of money of his own. Mr Grunhut, as a long time solicitor to the two brothers, knew this from the transactions, which had taken place between them during the last year or two. He then asked the court to release some of the money so that the widow could still run the boarding houses. He also explained that it was usual for Arab seamen to leave belongings with the boarding house keeper when they went to sea, and a considerable portion of the money belonged to boarders.

The first witness to be called was Abdul Salah, an Arab fireman. Abdul Salah stated that he was in 63 Thrift Street on the night of the murder, also there, besides other boarders, were the deceased, Faid Abdula, the deceased's wife, the deceased's brother, Nassar, and Mr Warhub, another Arab boarder. He said that Faid Abdula went across to 4 Thrift Street to look after the baby. Shortly after Mr Warhub followed to go to his room but came back raising the alarm that Faid was lying injured, whereupon they all rushed to No 4. He was asked if Mr Warhub had been a long time coming back to raise the alarm, he said no; he had come back almost immediately. He was then asked where Nassar Abdula was during this time. He replied that Nassar was sitting in No 63 reading and translating from a newspaper and that he had not left the room until the alarm was raised. In reply to a question about whether anybody had interfered with the deceased's clothing at the time of their arrival at No 4, Abdul Salah said that no one had, however, Nassar was touching the deceased on the breast and calling out: 'My brother, my brother.'

The Deputy Coroner, after the Chief Constable gave his evidence and other witnesses had been called to testify what they had seen or heard on the night of the murder, began his summing up to the jury. Mr Shepherd stated that since no one had seen the murder committed then they had to rely on the indirect evidence that had been given. As to the property of Faid Abdula, it is quite natural for a person to take possession of the deceased relative's valuables, but it is quite extraordinary for that person to say they have been stolen by the person who had murdered their relative. As to robbery being the motive for murder, it was obvious that Nassar was not in dire need of money as the money found in his possession far exceeded the amount that was stolen. It has been rumoured that the two brothers were contemplating returning to their own country in the future and that a dispute may have arisen in regards to Faid's white wife.

After an absence of a few minutes the jury returned with a verdict of wilful murder against Nassar Abdula. The Coroner sent him for trial.

At Nassar Abdula's trial at the Durham Assizes on Saturday 28 June 1919 Judge McCardie said in his summing up that the points against Nassar Abdula were the possessions of his dead brother's property, his conduct and the lies he had admitted. The points in his favour were that there was no quarrel between the two brothers, that both the brothers seemed to have been doing well in both of the boarding houses. That the clothes Nassar was wearing at the time of the murder were the same as the ones he was wearing when arrested and that

Above and below: *Aerial views of Mill Dam Quay scene of the 1919 riots.*

the clothes had no blood stains on them. The hairs that were found in the deceased's hand remains unexplained but the point is they did not match Nassar Abdula's hair. There were also witnesses that stated that Nassar Abdula was reading a newspaper at 63 Thrift Street at the time of the murder.

The jury retired to consider their verdict and returned with the verdict of not guilty. Nassar Abdula was awarded costs for his defence.

No one else was ever arrested for this murder, so it remains a mystery. Was it the brother who stood to inherit from his brother as they had both made wills out in each other's

favour. One of the boarders who lodged with the brothers, as some only lodged for single nights, could have been the murderer. It was common practice and knowledge for lodging housekeepers to look after money and valuables for their lodgers while they were away or about town. On the day of the murder Faid Abdula had travelled back from Sunderland after doing business there. It was said that on the train back he had met quite a few Arabs who were travelling to the courts for their trials in connection with the Arab riots that had occurred in the Mill Dam area of South Shields. In fear of going to prison a lot of them had given their money and valuables to Faid Abdula to look after for them. So, at the time of the murder it may well have been known by quite a few people that Faid Abdula had in his possession more money and valuables that he would have normally had.

The Arab Community

The town's sea faring tradition first brought Arabs to South Shields in the nineteenth century. These were from the Yemen on the southern tip of the Arabian Peninsula. They began to settle in riverside districts like Holborn. This has a claim as the first Islamic community in Britain.

During the First World War many Yemenis served in the Merchant Navy as stokers and firemen. After the war with unemployment levels rising the fact that Yemenis were getting work on ships at South Shields led to riots.

The Arab Riots
4 February 1919

On 4 February 1919 nine Arabs were signed on as a ship's crew at one of South Shields' numerous Yemeni-run boarding houses. When they went down to the National Union of Seamen's offices at Mill Dam Quay the officials said they had not been properly hired and went out to select a local white crew. The Arabs tried to stop them and riot ensued. The *Sunderland Daily Echo* of the following day reported: 'It appears that there is great friction between the two races owing to the returning British seamen demanding to be reinstated in the places which the Arabs have taken during the war. The quarrel yesterday attracted a crowd of British and Arab seamen and others, and quickly stones, bottles, and bricks were flying in all directions. The Arabs reached the higher level in Holborn, and rained down missiles upon their opponents.

The police were sent for, and on their arrival "rushed" the Arabs, but the latter soon regained the upper hand, and the crowd were forced up Coronation Street. About this time revolver shots were heard coming from the Arabs' direction, and an Arab was seen flourishing a knife over a foot long. He began stabbing right and left, wounding some of the lookers-on.

At this point a detachment of naval men from one of the ships in the harbour came on the scene, with fixed bayonets, which somewhat quietened the Arabs, and later a company of soldiers. The disturbances were thus quelled. Several Arabs were arrested.'

When a dozen Arabs found themselves in court after the riot the judge took their side. He passed only light sentences on nine men and acquitted the others.

VENGEANCE

MAY 1919

On 3 June 1919, an inquest was held into the death of Mohamed Farah and Ahmed Ahmet, both seamen who had lodged at 93 East Holborn, an Arab lodging house. The inquest was held at the Police Buildings and was conducted by Deputy Coroner Mr R. A. Shepherd; the magistrates were Ald J. R. Lawson and Ald D. Richardson. Also present was Dr Seid Abdul Majid, barrister, and also President of the Islamic Society, who had been briefed to appear at the Assizes.

Five people stood accused of murder. Ali Said (33) of 1 Henry Nelson Street, South Shields, who was the boarding house owner of 79 East Holborn, South Shields. Abdulla Said (33) a seaman and lodger at 79 East Holborn, Farra Allup (29) whose address was given as the ship *S.S. Ivingtill*, Hassem Hamed (32) seaman and lodger at 79 East Holborn, Hassen Mohamed (23) seaman and also a lodger at 79 East Holborn.

Mr Victor Grunhut who appeared for the Public Prosecutor gave the details of the case, which led up to the five men being accused of murder.

Ali Said kept a boarding house at 79 East Holborn. His lodgers were mainly Arab seamen, being firemen and donkeymen. Ali Said's was one amongst many similar boarding houses in the Holborn area of South Shields at this time, 1919. The Holborn area was densely populated by Arabs, and in particular by the lower class of seamen who sought lodgings there, it being close to the docks. One of Ali Said's countrymen, Abdul Zaid, also kept a boarding house at 93 East Holborn, he also took in mainly Arab seamen. There was some rivalry between these two men, which caused bad feelings to exist. These bad feelings for each other had also spread to their respective lodgers, causing a feud between the two lodging houses. It was this rivalry and feud that eventually led to the death of Mohamed Farah and Ahmed Ahmet and to a charge of murder against the five accused.

On Wednesday, 22 May 1919, a disturbance had taken place outside the premises of Abdul Zaid's boarding house. A fight had taken place between the lodgers of Ali Said and Abdul Zaid. This fight had also led to Ali Said's windows being broken by a stone and a bottle being thrown through them. When the police were called the men had fled to their respective boarding houses.

On the Wednesday evening Ali Said had called a meeting of his lodgers and was discussing the day's happenings with his men when the police called in the course of their investigation into the disturbance earlier in the day. When the police had left, after making their enquiries, Ali Said was reported to have said to his men that they were a bunch of women and that if they were men then they would go out and kill.

Said Hasson, a boarding house keeper of 25 East Holborn, at Ali Said's request, went to 79 East Holborn at 11.45 pm the same night. In his evidence, Said Hasson told the court what

took place. Ali Said had asked him if any of his, Said Hasson's, lodgers had been involved in the disturbances. Said Hasson replied that his lodgers had all been asleep and had not been involved in any fighting. Ali Said had then told the men present that, tomorrow, if they saw any men from Abdul Zaid's house they were to kill them straight away. Said told Ali that he should not tell the men such things, that Ali was the boss in the house and that he should try and stop the trouble. Ali had replied: 'I cannot settle the trouble before I kill one myself.' Said told Ali to go home to his private house before the men started to take notice of what he was telling them. As Said was leaving 79 East Holborn to return to his own boarding house he overheard Ali saying to the men: 'Tomorrow morning go and kill anybody and smash windows.' One of the people inside the house at this time, Hassen Ali, who also gave evidence at the inquest, had overheard Ali Said say to his men: 'You go outside and kill them.' Ali Said had then passed a white handled knife to Hassen Hamed telling him that if he killed two or three of them he would stand up for him in court. When Hassen Ali intervened, telling Ali Said that what was being said was good for nobody, he was told to shut up by Ali. Hassen Ali later told the court that when he was in East Holborn at the time of the killings he had seen Hassam Hamed stab Ahmed Ahmet with the same white-handled knife.

On the Thursday morning at 5am according to Mohomed Huckble giving evidence, Ali Said had told Mohomed Huckble, who also kept a boarding house at 27 Nelson's Bank about the trouble. Ali told Mohomed that he was afraid that the boarders at Abdul Zaid's boarding house wanted to kill him. Mohomed Huckble accompanied Ali to the house of Abdul Zaid where he made an attempt at reconciliation between the two men. There was some kind of settlement reached and Mohomed suggested to Ali that now a settlement had been reached the two men, Ali and Abdul, could proceed to settle the bad feelings between the boarders of the two houses. Ali Said was alleged to have said: 'No, let them settle it between themselves. We have nothing to do with them.'

Mahomet Salie, who ran a coffee house in East Holborn, according to his evidence at the inquest, acting on a request from Mohomed Huckble, visited Ali Said's boarding house at about 8am on the day the killings took place. He told Ali that there should be no more trouble and that he, Salie, would try and settle things. Ali Said had told him: 'No, we want fighting.' When asked why, Ali replied that his friends had been struck.

After the stabbings had taken place in East Holborn, the police immediately went to Ali Said's boarding house. PC Gardener first searched the rear of 79 East Holborn, after the search he came round to the front where he met Sergeant Boyce and Detective Walker, who had just arrived. They knocked on the front door several times demanding admission, but it was only when they started an attempt to force the door that it was opened by Ali Said. When he was asked why he did not open the door Ali said that he was frightened and thought there was going to be some trouble. Sergeant Boyce asked if there was anybody in the house who had anything to do with the killings, Ali replied: 'No.'

PC Gardener searched the house and coming to the bathroom door he found it locked. He forced open the door and found Hassam Mohamed, and crouching down in a corner, amongst some lumber, he found Farra Allup. He told both men that he was arresting them in connection with the killings. Both replied: 'Me no fight, me no knife.'

Detective Walker, looking into one of the rooms, found Hassem Hamed underneath one of the beds, clinging to the laths underneath the bed. He arrested Hassem, also in connection with the killings. Hassem said: 'me no savvy.' On searching the bed, Detective Walker found the white handled knife in the same bed, hidden amongst the clothes. There was blood where the knife had been.

One of the many boarding houses for Arabs in East Holborn.

As PC Gardener and Sergeant Boyce were leaving the house with their prisoners they met Hassam Ali, who pointed at one of the men and said: 'He killed one of them.'

At the inquest, Mr Victor Grunhut, said that the evidence showed that Ali Said was the principal and instigator of the murders and that several witnesses had heard him excite the men into killing, not once but several times. When Ali Said was told that this was wrong, Said had replied that he did not care if he had to hang for it and that if the men were to do what he asked them, go out and kill, he would go to court and stand by them. This proves Said knew that what he was doing was wrong and was aware of the consequences. In spite of all this he still handed the prisoner Hassen Hamed the dagger and it was this dagger that had killed Ahmed Ahmet.

After all the evidence was given, Mr Shepherd, the Deputy Coroner, began his summing up. He stated the following. 'It seems to me that Ali Said is the man at the bottom of the

whole trouble. I don't think there would have been any blood shed if Ali Said had cared to have said something to the men which would have stopped this fight on the Thursday morning. Ali Said was a boarding house keeper, and had a certain power over these men, and it was he who urged these men to go out into the street and "kill, beat, or do anything you like" to Abdul Zaid's boarders.

Men like his fellow prisoners probably did not have the same sense as himself. He had been in the country probably considerably longer, they having come over during the war to man ships. Having used the expressions he had used to the men who had not been out of their country very long was without doubt inciting them to such an extent that they would go out and do anything they thought of. There was no doubt that Ali Said was an accessory before the fact.'

After the jury returned from considering their verdict, the foreman, Mr Thomas Gibson, said that in each case death was caused by haemorrhage through being stabbed. Farra Allup did the stabbing of Mohamed Farah and Hassem Hamed did the stabbing of Ahmed Ahmet. The other prisoners aided and abetted the stabbings and Ali Said was an accessory before the fact.

The five accused were committed for trial on the charge of wilful murder.

At their trial, Hassam Mohamed and Ali Said were found not guilty. Hassem Hamed, Fara Allup and Abdulla Said were found guilty of manslaughter. Abdulla Said was sentenced to five years penal servitude. Hassem Hamed and Fara Allup were both sentenced to seven years penal servitude.

MURDER ON BOARD

JULY 1920

Near to midnight on Thursday, 15 July 1920, a shooting took place aboard a ship docked at Tyne Dock, South Shields. The vessel was the coal carrying Sowels Point, an American steamer flying the American flag. The ship had arrived at Tyne Dock a few days before from Sweden. The crew of the ship was of a highly mixed race.

When the police were called to the incident on board ship they discovered that the shooting had been a fatal one and that the dead man was one of the ship's cooks, a Dutchman named Mauten Cornelius Fyke. Suspicion fell on the boatswain, Panoghisth Ellenois, a Creek. He was taken into custody on suspicion of shooting Fyke.

On the Friday morning, 16 July, the prisoner was brought before the South Shields Police Court and was assigned before Messrs J. H. Edwards and I. Sykes. The Chief Constable, Mr William Scott, gave evidence of the enquiries that the police had made amongst the crew earlier that same morning and outlined the circumstances that led to the fatal shooting.

Both the prisoner and the deceased were members of the vessel's crew. Apparently, and according to custom of the port, the crew were allowed shore leave while their vessel was in dock. On the evening of 15 July members of the crew came ashore and made their way to the town centre to have a drink. Some of the crew, including the deceased and the prisoner, decided to spend the evening drinking in North Shields. After a good deal of drinking a serious quarrel broke out amongst the men. This quarrel continued on the ferryboat bringing them back to South Shields and also on the foyboat, which took them back to their ship. On the ship the trouble continued and the prisoner, Ellenois, went to his cabin.

At some point Ellenois tried to leave his cabin but found that the door would not open easily. As the cabin doors opened outward it was obvious to him that someone on the outside was pushing on the door preventing him leaving the cabin. It appears that he threatened to kill the person, who was apparently Mauten Fyke, who in return was stated to say: 'Two can play at that.' Shortly after this exchange of words a shot rang out and Mauten Fyke fell to the floor.

When the police were called they found Mauten Fyke lying on the ground with a gunshot wound to his breast. There was also a mark on the side of his head that may have been caused by his falling to the ground. There was a loaded revolver in his hand and a live cartridge lay beside him. Fyke, at the time, was not dead but died shortly after the police arrived and his body was removed to the mortuary.

At the Police Court the only witness called was Sergeant Ogg. He gave evidence of his visit to the ship, accompanied by another officer, shortly after the shooting. He went into the cabin where the accused, Ellenois, slept and questioned him. Sergeant Ogg told Ellenois that the cook had been murdered and did he, Ellenois, have any firearms, Ellenois replied: 'Me

The Penny Ferry at the Shields Landing waiting to take passengers to North Shields. The crew of the Sowels Point *used it when they decided to spend the evening in North Shields.*

The above photograph is of the Ferry Hotel situated next to the ferry landing. A place to have a last drink before boarding the ferry and the first place to have a drink after disembarking from the ferry.

The Ferry Tavern, formerly the Ferry Hotel, just after its closure in 1999. It has now been demolished.

no shoot.' Sergeant Ogg then began to examine the cabin. There was a ventilator in the door of the cabin by which a shot could be fired through, but there were no scorch marks on the ventilator. On later examination of the deceased's clothes, scorch marks were found. There was a porthole in the cabin which was in the open position and which could have afforded an opportunity of disposing of a weapon. Sergeant Ogg noticed a bucket of dirty water in the cabin and when this was emptied a revolver cartridge case was found.

The Chief Constable asked for the prisoner to be remanded for eight days so that further enquiries could be made. He added that the American, Dutch and Creek Consuls had been notified.

On 23 July Ellenois appeared again in the Police Court on remand on the charge of having murdered Mauten Cornelius Fyke. It was expected that the crew members of the ship were to give evidence, but this was not to be. The Chief Constable told the magistrates that the vessel had sailed from the Tyne a few days before, taking with her all the men that the police had intended to call as witnesses and as a result the case could not be proceeded with. He said that serious questions had arisen as a result of the vessel's sudden departure and a report of the circumstances of the case had been made to the Public Prosecutor, who was negotiating with the American authorities.

The prisoner, Ellenois, was further remanded for eight days.

On Monday, 30 August, at the conclusion of a coroner's enquiry an open verdict was recorded on the deceased. No other verdict could be reached because of the lack of witnesses to make further enquiries. The prisoner, Ellenois was allowed to go free.

JILTED LOVER

MARCH 1923

'Jenny Jarrow' (25) was shot dead in 107 East Holborn, an Arab refreshment house, in the Holborn area of South Shields. Her maiden name was Jane Brown until she married an Arab from South Shields named Nagi. Nothing is known about Mr Nagi, apart from that he died about twelve months prior to the shooting of Jane Brown. Before this marriage Jane had lived with her father at 17 Curry Street, Jarrow. After her husband had died, Jane found employment in an Arab refreshment house, but often slept at the house of her father. Jane liked her drink and would often be seen drunk around the Holborn area of South Shields where she acquired the nickname of 'Jenny Jarrow' from the local people.

This case caused considerable interest in South Shields at the time, large crowds assembled outside the court buildings where Mr A. E. E. Boulton, the Deputy Coroner, was conducting the inquest on 13 March 1923. Inside the court, Hassan Mohamed (33) an Arab fireman, who had been arrested for the shooting, was to be present throughout the hearing. A solicitor did not represent him, as, according to himself, he had no money for one.

Jane Brown's father, a driller, gave evidence as to the identity of the deceased and stated her age as 25 years and that she had been married to an Arab by the name of Nagi, who had died twelve months before. His daughter worked in a refreshment house in the East Holborn area of South Shields, but after work she slept at his house, 17 Curry Street, Jarrow. Mr Brown had last seen his daughter alive at seven o'clock on Sunday night.

Irene Rab, a young widow, of 32 Woodbine Street, South Shields, told the court that she had known Jane for a few years, and that for the past few months Jane had been keeping company with the prisoner, Hassan Mohamed, who was a sea-going fireman. Hassan used to give Jane money to keep her while he was away at sea. Irene Rab told the court that sometime last week Jane had went to Cardiff to meet Hassan from his ship and that they had both returned to Shields on the Friday morning, 9 March. On the Sunday night she had seen them both together, they had been drinking, but Jane did not appear to be very drunk.

On the Monday afternoon Irene Rab had been told that Jane, who was very drunk, had been 'making trouble' in some of the Arab shops in Holborn. Irene went to see what all the fuss was about and eventually found her friend in the yard of a shop. She was very drunk. After a while she managed to persuade her friend to come out into the street. Jane was asking if Irene had seen Hassan and when Irene had told her that she had not seen him Jane called her a liar and said that she would go and look for him. Irene accompanied her to several shops, but they could not find Hassan. In one shop Jane had started an argument with the owner and broke some eggs, when the owner left the shop to call a policeman, Jane left the shop also. At this point the friends parted. The next time Irene saw Jane was about 4.30 pm on the same day. This time Jane was in the company of Hassan Mohamed. Hassan

had a hold of her coat and was pulling her and she was telling him to leave her alone. Irene said that Hassan was trying to keep Jane quiet but Jane refused to do so and was clawing at Hassan's face, she also took no notice of Irene's pleas to be quiet. Still quarrelling, they all went into an Arab refreshment house. Inside, Jane got a hold of Hassan by the throat and was trying to choke him saying that she would swing for him; she was also using foul language in Arabic. While they were struggling they fell over a bench seat and at this point someone stepped in between them to sort out their trouble. Jane ran out of the shop with Hassan following her.

When Hassan Mohamed was asked if he had any questions to put to Irene Rab, he replied, through an interpreter, 'No, all true.'

Salam Ali, a refreshment housekeeper, of 107 East Holborn, said that he had known 'Jenny Jarrow' for about three years. He supported Irene Rab's story about the argument in his refreshment house, then went on to describe what had happened after this. Jane Brown had later come back inside his shop and had sat down on a sofa beside three men. Hassan had then come in and went and sat down in a chair beside Jane. After about five minutes he got up and left the house but was back again within three minutes. He put his hand in his pocket and drew out a revolver, which he aimed and fired at Jane Brown from the doorway. He turned around and tried to run out of the house but Salam Ali grabbed hold of him and shouted for help. Another Arab, Sam Ali, helped to hold Hassan and take the revolver from him while another man went for the police. When the policeman came he was told what had happened and on going into the kitchen he found Jane Brown lying on the sofa dead.

Hassan Mohamed was asked if he wanted to put any questions to Salam Ali, and he said: 'me come three times and say, let me have my girl out! She no come. You want to marry her?'

'No, no,' replied Salam Ali. 'She just came in.'

The Coroner asked Salam Ali if he had wanted to marry 'Jenny Jarrow'.

'No, I no want to marry her,' replied Ali with emphasis.

Hassan Mohamed then started to make a long statement in Arabic to the interpreter but was advised by the Coroner not to say anything at this time.

Dr Marks, the police surgeon, gave details as to the post-mortem he had carried out on Jane Brown. He said that the bullet had passed through three vital organs, the heart, stomach and kidneys. He said death would have been very quick.

At the end of the Coroner's enquiry the Deputy Coroner, Mr A. E. E. Boulton made, what would be today, a highly prejudiced statement to the jurors that would have had serious consequences to him if said in court today. At this time, in the 1920s, it shows just how much unrest there was against an ethnic group of people and how high up the prejudice went. He says: 'It is a very sordid case, and I am sorry to say that in my experience of inquests at South Shields I have come into contact with a number of cases in which white women have married coloured men. I feel very strongly on the point, not that it has any bearing on this case, but it seems a great pity that white women should marry men of a different nationality altogether and that trouble more or less arises from such unions.

I don't consider it is fair to the children who may be born in any such marriage, and it seems to me that steps should be taken to prevent these unions if possible. I am sure we should not have been here today had such a wedding as was contemplated in this case not been about to be celebrated.'

There were a lot of bad feelings at the time towards the Arab population in the Holborn area of South Shields, especially towards white women mixing with the coloured population

The Rose and Crown, Holborn as it is today. In 1923 this area had a large Arab population. The Rose and Crown is just about the only original dwelling building in this area now.

of the town. The *Shields Gazette* printed, in their letters column, quite a few totally biased comments against coloured people. I do not think it would serve any purpose to go into the details of them here. Fortunately the *Gazette* also featured the favourable comments also.

Bad feelings towards the Arabs finally erupted into violence known as the 'Mill Dam Riots', which was mainly against the sea-going Arabs. South Shields Library Archives contain books solely about these riots.

The jury retired, and after a few minutes returned with a verdict of death by shooting against Hassan Mohamed. He was committed for trial on the Coroner's Warrant.

At the Durham Assizes, Hassan Mohamed appeared before the Chief Justice (Lord Hewart). Hassan pleaded not guilty to the charge of murder. Mr L. R. Lipset prosecuted for the Crown and Mr A. P. Peaker defended.

Counsel gave details of the background to the case. The deceased woman (25) was the daughter of Michael Brown who she lived with at 17 Curry. Street, Jarrow. She was formerly married to an Arab named Mohammed Nagi, who died about a year previously. Some people knew the deceased as Jane Nagi and to others as Jane Brown, she was also known as 'Jenny Jarrow' because of living in Jarrow. After her husband had died she lived with her father but kept up her acquaintances with the Arab population in the Holborn area of South Shields and worked there during the day in service at an Arab refreshment house. During the nine months prior to her death she was keeping company with Hassan Mohamed. During this period she had received money from him from time to time. There seemed to have been an understanding between them that they would eventually get married, despite the fact that Jane seemed to have had a drinking problem and would get drunk every so often.

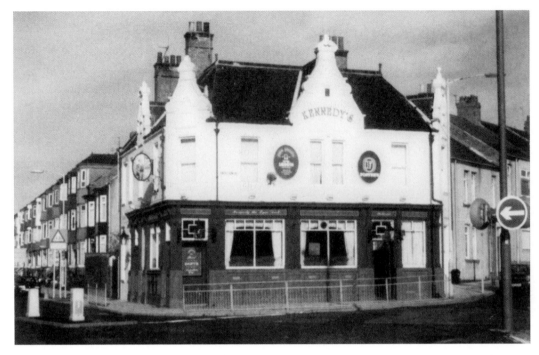

A popular pub in Tyne Dock at the time of the crime. Kennedy's still retains many characteristics of the time.

On 7 March she went to Cardiff to meet Hassan from his ship, which was berthed there, and they both returned to Shields. Not much is known about their movements during this time from the Saturday of their return until Monday, 12 March.

Irene Rab repeated the evidence that she gave at the inquest at South Shields. She had witnessed the argument between Hassen and Jane at the restaurant on the afternoon of 12 March. She said that Jane was very drunk but Hassan seemed to be sober. It was her impression that Hassan was trying to get Jane away because he was afraid that she might get locked up for being drunk and disorderly. Hassan did not use any violence towards Jane, but had tried to help her. Jane was very drunk and did not appreciate this kindness and was violent towards Hassan and was swearing at him. A policeman had cautioned the pair of them about their behaviour and they were both sent away from the restaurant.

Salam Ali was questioned about the events that had happened in his restaurant on the evening leading up to the fatal shooting. On being asked, he denied that intoxicating liquor was sold at his restaurant. He related that Jane Brown had returned to his premises in the evening where she had an argument with Hassan Mohamed, who, after leaving for a few minutes, had returned and fired the revolver at Jane.

Hassan Mohamed then gave evidence. He stated that he had first met Jane about a year before when he was looking for a man who owed him £25. They began a relationship, with Hassan seeing Jane between his voyages at sea. On his docking at Cardiff, in the March of 1923, Jane had travelled to Cardiff to meet him. He said that on this occasion he had given Jane £20. They both returned to South Shields on Friday morning, 9 March. On Saturday morning he received £8 off the loan of £25 from the previous year. He gave Jane £6 of this money.

On the day of the shooting, Monday, 12 March he had met Jane between 2 and 3 pm and she had promised to meet him later at her father's house in Jarrow. She was not there when he called so he went to look for her. He was told at this time that Jane had been seen drinking with an Arab named Sam Ali at Tyne Dock. He knew that Sam Ali would now be at Salam Ali's restaurant. When he got there he found that Jane was also there and that she was sitting on an Arab's knee, Jane at this time was very drunk.

Hassan then had words with the owner of the restaurant, Salam Ali; he told Salam Ali that he, Hassan, and Jane were to be married on 14 March. Salem Ali was then alleged to have grabbed Hassan by the throat and had shook him. At this point, Sam Ali, who was also there, got involved in the struggle and allegedly threatened to shoot Hassan. Hassan said that it was during this struggle that a gun was fired. He denied firing the revolver and said that the gun was in Sam Ali's hand and that it was Sam Ali who had shot Jane. Hassan believed that Jane was not shot intentionally.

Both Sam Ali and Salam Ali denied that this was the way it had happened and both stuck to their previous statements.

The Lord Chief Justice told the jury that a verdict of manslaughter could not be considered. The jury retired for a few minutes then returned with a verdict of murder. Hassan Mohamed was then sentenced to death.

THE POLICE

At a meeting in 1829 in the Vestry of St Hilda's it was decided that the town should employ 12 watchmen for night duty under the command of Captain James Robb. Within a few years constables were appointed and after the town became a Municipal Borough in 1850 the Police Force continued to grow:

1869 – 40
1886 – 59
1900 – 105
1906 – 127
1921 – 139

The introduction of the police box system in August 1930 had a dramatic effect on the Force, reducing it to 124 men. Then two years later when automatic traffic signals were introduced it fell further to 120.

The sum spent on policing the town soared in the first two decades of the twentieth century:

1901 – £12, 868,
1911 – £16,735
1921 – £44,989

Is this an early Tardis in South Shields? The introduction of these police boxes in South Shields in 1930 was to cost the local Police Force jobs.

1902.	King St., Market Place, E. & W. Holborn & Neighbourhood							Other Districts of the Borough.						
	Residents.			Non-Residents.			Total Persons Resident and Non-Resident.	Residents.			Non-Residents.			Total Persons Resident and Non-Resident.
	Total.	Males.	Females.	Total.	Males.	Females.		Total.	Males.	Females.	Total.	Males.	Females.	
Qr. ended Mar.	104	60	44	96	73	23	200	107	74	33	39	34	5	146
,, June.	123	67	56	124	107	17	247	96	74	22	60	52	8	156
,, Sept.	113	74	39	149	114	35	262	121	90	31	60	45	15	181
,, Dec.	80	49	31	137	106	31	217	111	85	26	70	60	10	181
TOTALS......	420	250	170	506	400	106	926	435	323	112	229	191	38	664

Above and below: *A comparison of summonses for drunkenness in the town in 1902 and 1924. The high number of non-residents summoned could be accounted for by visiting seamen. The dramatic drop in drunkenness over the 22 year period might be in part due to the strength of the beer. During the First World War the strength of beer was reduced and was never returned to its pre-war levels.*

1924.	King Street, East and West Holborn and Neighbourhood.						Total	Other Districts of the Borough.						Total
	Residents.			Non-Residents.				Residents.			Non-Residents.			
	Total	Males	Females	Total	Males	Females		Total	Males	Females	Total	Males	Females	
Quarter ended March	27	24	3	28	28	..	55	28	24	4	14	14	..	42
,, June	30	24	6	45	42	3	75	38	36	2	30	30	..	68
,, Sept.	48	43	5	41	38	3	89	42	41	1	31	28	3	73
,, Dec.	33	26	7	25	25	..	58	49	43	6	19	17	2	68
Totals	138	117	21	139	133	6	277	157	144	13	94	89	5	251

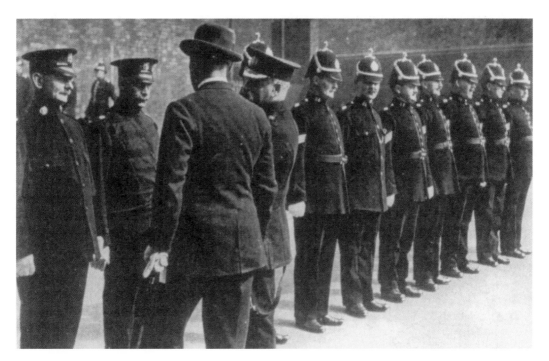

Now, Now, what's all this here then? A police inspection taking place, most likely at the back of Keppel Street police station.

Police uniforms in the early 1900s were changing dramatically from the middle to late 1800s as can be seen from the uniform descriptions and the uniform in this picture.

Tenders For Police Clothing
1904

The committee considered the tenders received for the supply of the summer and winter issue of Police Clothing for 1904.

Mr Wood, Tailor, attended and reported on his inspection of the various samples of cloth. That the following tenders be accepted for the supply of the following clothing, viz:

For Superintendent – 1 Blue Cloth Braided Patrol jacket, at £2 15s 0d. 1 Pair Blue Cloth Braided Trousers, at £1 2s; and 1 Cap, at 17s 6d – Jas Smith & Co, Derby.

For Inspectors – 5 Blue Cloth Braided Patrol jackets, at £2 10s each; 5 Pairs Blue Cloth Braided Trousers, at £1 each; 1 Double Breasted Serge Suit, at £2 10s; and 6 Caps, at 12s 6d each – Jas Smith & Co, Derby.

For Sergeants and Constables – 107 Blue Cloth Tunics, at 22s each; 107 Pairs Blue Cloth Trousers, at 11s 6d each; 107 Helmets, at 6s 3d each; 12 Silver Chevrons and Crowns, at 8s each – Jas Smith & Co, Derby. 19 Dozen Pairs White Cotton Gloves, at 7d per pair - Hebbert & Co, London.

Winter Issue

For Superintendent – 1 Pair Blue Cloth Braided Trousers, at 22*s* and 1 Mackintosh Coat, at 30*s* Jas Smith & Co, Derby. 1 Pair of Fur-Lined Black Kid Gloves, at 3*s* 9*d* – Warren & Co.

For Inspectors – 6 Pairs Blue Cloth Braided Trousers at £1 each; and 3 Mackintosh Coats, at £1 7*s* 6*d* each – Jas Smith & Co, Derby. 6 Pairs Fur lined Black Kid Gloves, at 3*s* 9*d* each – Warren & Co.

For Sergeants and Constables – 107 Pairs Blue Cloth Trousers, at 13*s* 9*d* – C.W Charleson, South Shields. 18 Dozen Pairs Black Ringwood Gloves, at 11*d* per pair – Hebbert & Co.

And that contract be prepared by the Town Clerk in respect thereof, and the Corporate Seal affixed thereto.

(From the Police Reports, 1904)

SOUTH SHIELDS POLICE REPORT FOR THE YEAR ENDING 31 DECEMBER 1905

Crime In South Shields An All Round Decrease

The Chief Constable of South Shields, Mr W. Scott, issued his report on the criminal and other police statistics for the past year. As usual it contains much information of public interest.

Population: 1000,858

Police Force: 119

Total number of persons proceeded against: 4,415

Drunk: 1,084 – 859 males and 225 females

Beggars: 78

Sleeping out: 32

Prostitutes: 223

Lost children reported to the police and restored to parents: 1,767

Minor Larceny: 264. Persons caught – 220 being 189 males and 31 females

Manslaughter: 1 by a female who was sent to prison

Suicide: 7 – 6 male and 1 female. Hanging – 3, Cutting throat – 2, Poisoning – 2

Attempted suicide: 10 – 3 males and 7 females

Chief Constable William Scott in full uniform and medals with his wife.

A GRUESOME FIND

JULY 8, 1905

Mary Stone, a married woman, living in Morrison's Court, Harding's Bank, South Shields, was taking her turn in cleaning the communal outside closet in the back yard of the building. Helping her was Ellen Green, wife of Alexander Green, labourer, also of Morrison Court. There were seven tenants in the building and each took their turn at cleaning the closet out. On this Saturday, 8 July 1905, regrettably, for her, it was Mary Stone's turn, and for what followed she was thankful that her friend Ellen had offered to help with the cleaning.

During the course of their work they encountered a problem in getting the water to drain away. After a few unsuccessful attempts, Mary Stone picked up a long forked iron rod and stuck it into the drainpipe to dislodge the blockage. The hook caught on to something and Mary started to pull out whatever it was that was blocking the drain, expecting it to be an accumulation of debris. Instead, to Mary's shock, what came out was not debris as expected, but a newborn baby. The body was that, of a fully developed male child. The body was green and decomposing. At the sight of this gruesome find, Mary, quite justifiably, fainted away. Ellen Green managed, after a short while, to bring Mary around. After their initial shock they both went for the assistance of a policeman.

P.C. William Ramsay was on duty in King Street at half past twelve on the afternoon of the same day when he was informed of the find. He went along to Harding's Bank and inspected the child's body where it was lying in the back yard. P.C. Ramsay had the body removed to the police station.

P.C. Ramsay questioned Mary Stone and Ellen Green about any information that they may have as to how the body came to be in the drainpipe. Also if they knew of any woman near about who had been pregnant? Mary Stone informed P.C. Ramsay that she had suspicions about Hannah Francis, an eighteen-year-old girl, who also lived in Morrison's Court.

Hannah Francis lived with her father, her mother being dead, in the house next door that shared the same back yard where the body was found. She had come to Harding's Bank about four months ago. Mary Stone said that she had her suspicions that Hannah was pregnant, but had had no conversation with the girl on the subject. The last time she had seen the girl was when she saw Hannah looking out of her window on the Thursday last, the 6th, but she had not seen her in the closet. Ellen Green added that she knew Hannah Francis and often spoke to her. She said that Hannah used to hawk fish sometimes around the doors and was a respectable young woman. Ellen, however, did notice that Hannah Francis was pregnant.

P.C. Ramsay, acting on this information, went to the house 7 Harding's Bank where Hannah and her father occupied one room. There he saw Hannah Francis, who was now no longer pregnant. He told her that he was going to arrest her on suspicion of having concealed

the birth of her child. Hannah said that she would tell the truth at the police station. At the police station she was cautioned and charged with concealment of birth. Hannah made a statement admitting that she had given birth to the child found in the water closet. She was then seen by Dr Sutherland, who ordered her to be admitted to the hospital.

Detective Sergeant Bruce, giving evidence at the inquest, said that he was called upon to investigate the incident that had occurred on the Saturday. He visited the room that Hannah Francis occupied with her father. On searching the room he found some articles of female clothing concealed in a sack in the bottom of a closet.

Dr Sutherland, a police surgeon, had made an examination of the body and stated that it was a fully developed male child and that the child had arrived at its full time. The body was green and decomposition was in progress. It was in his opinion that the child had been born alive and had breathed. The cause of death was suffocation, most likely due to lack of care and attention during birth and after birth.

In his summing up to the jury, the coroner told them that they would have to consider three important questions. First, that the child was born alive. A verdict of murder could not be given unless that was vitally clear. In this case there could be no doubt after what Dr Sutherland had said when giving his evidence. Secondly, was this the child of the accused prisoner and thirdly, were the circumstances surrounding and attending the birth of the child such as to make the mother guilty of murder or manslaughter, or neither of these crimes.

On the jury's return, their verdict was wilful murder. Hannah Francis was committed to the Assizes on the capital charge; that she did on, or about 8 July did feloniously kill and slay her newborn child.

Mr Blair, for the defence, made an application for the defence of the prisoner under the Poor Prisoner's Act of 1903. He said that neither his client or her family had any means, he asked the magistrate to make an order for the prisoner to be defended and the expenses paid. The defence being that she was ignorant of anything being the matter with her. She went into the water closet not knowing what was wrong, came away and did not tell anyone anything. The application was granted.

Up to the time of going to print, I can find no record of the eventual outcome of this case.

'DUMPED'

MAY 1910

On Wednesday, 5 May 1910, an inquest was held at the Municipal Buildings, Wallsend, Tyne & Wear, into the death of a newly born male child, whose body was found in back of High street, Wallsend, on Sunday 22 May.

Patrick Sweeney, 10 years old, of 23 Portugal Place, Wallsend, gave evidence of finding the body. He stated that as he was walking at the back of High Street East he saw a brown paper parcel lying on the ground. Curious, he opened the parcel and found that it contained the body of a newborn baby. He told some other boys of his find and afterwards reported it to the police.

Coroner, Mr H. T. Rutherford, said that he hoped the police could come to some conclusion in the case. He said that this kind of case was becoming to frequent and that he had been looking through his records and found that this was the sixth case of its kind he had had to deal with since the beginning of the year, three being at Wallsend, two at North Shields and one at Ponteland. It appeared to him that it was as if Wallsend and North Shields were being used as 'dumping' grounds.

Mr Rutherford told the jury that he proposed to adjourn the inquest in the hope that police enquiries, now being made, would result in bringing the case to a satisfactory conclusion. For the benefit of the jury he had ordered a post mortem examination to be made, and that this had disclosed a very serious state of affairs.

On the same day at Wallsend Police Station, Lizzie Harris, a twenty three year old married woman, belonging to South Shields, was brought before the magistrates and charged with having wilfully murdered her infant child.

Supt. Pringle told the magistrates that at about 2pm on the Sunday afternoon, 22 May, at the Police Station he inspected a brown paper parcel. Contained in this parcel was the body of a male infant wrapped in a lady's undergarment, this undergarment bore a laundry mark. The brown paper bore an address label with an address on it for Benwell, Newcastle. After making enquiries he visited Lizzie Harris at a workshop in Clayton Street, Newcastle. She was asked to accompany him to Wallsend where he had arranged for her to be medically examined by a police surgeon. After the examination he charged her with having murdered her infant son on the 21 or 22 of May. She made no reply to the charge. Later on, Lizzie Harris made a statement, she said that a young man, whose name she mentioned, had nothing to do with the event. She said that she had brought the parcel to her mother's house and had taken it away the next morning. In the statement she said that she had a child a week past Thursday.

The court asked if Lizzie had anything to say, she replied 'no' and was remanded into custody until Tuesday.

On Tuesday 31 May at Wallsend, Lizzie Harris was charged with the murder of her newborn child.

Eliza Cotton, who lived with her husband John Cotton, at 40 Northcotte Street, South Shields, gave evidence to the court. She said that she had known Lizzie Harris since the latter's birth. Lizzie had come to live with her about four years ago when Eliza was living at Marlborough Street, South Shields, with her husband. On 23 April 1910, Eliza and her husband moved to 40 Northcotte Street and Lizzie moved with them. Shortly after moving to Northcotte Street, Eliza's father, Thomas Hall, and her 78-year-old aunt, Isabella Spoors, also came to live with Eliza. They both had previously lived at Benwell in Newcastle. Lizzie Harris shared the same room with Isabella Spoors.

Eliza Cotton said that for the past two or three months Lizzie had been complaining of feeling unwell. Eliza had advised her to go to the Infirmary as she believed it was the same complaint returning that had made Lizzie unwell about eighteen months ago, when, at that time, she attended the Infirmary. Lizzie had said that it was the same complaint and that her sitting at her occupation as a tailoress caused it. Lizzie had worked up to about three weeks ago. On 21 May at about 10pm Lizzie had come downstairs at Northcotte Street with a brown paper parcel in her hand. She asked Eliza for a bit of string with which to tie the parcel with. As she was tying the parcel, Eliza asked what was in the parcel and Lizzie had replied that it was underclothing. Lizzie had then left the house to go, Eliza presumed, to her mother's home at Wallsend, as Eliza had advised her to do because of her illness.

In court Eliza Cotton was shown the lady's undergarments that were found in the parcel containing the dead baby. She said that they were similar to the ones worn by Lizzie Harris also that the attached laundry label was the same that the laundry attached to goods sent from her house.

Margaret Bedford of Laburnum Avenue, Wallsend, the mother of Lizzie Harris gave her evidence. She stated that her daughter was a married woman, the wife of John Harris and that they had only the one child, which was now dead. Lizzie had been married for five years, starting marriage in Benwell, Newcastle. After about eleven months marriage she had a disagreement with her husband and had not lived with him since that time. Lizzie had returned to live with her mother after the marriage breakdown. After about three months Lizzie went into service at Mrs Thomas's Temperance Hotel, after about three months she left there and went to stay at Eliza Cotton's house at South Shields where she found work and served her time to be a tailoress and where she now worked at Messrs Wm. Woods of South Shields and North Shields. Mrs Bedford had only seen her daughter the once and that was about three months ago.

On 21 May Lizzie arrived at her mother's house carrying a brown paper parcel tied with string, which she placed on top of a box in a corner of the room. After a bit of talk both mother and daughter went to bed. Next morning they both had breakfast together. At this time Mrs Bedford complained about a bad smell coming from the parcel. Lizzie told her mother that it was a parcel she was delivering to Willie Thompson, a young man who worked in the same shop as Lizzie and who lived at 36 Laurel Street, Wallsend. Lizzie then got dressed, and picking up the parcel, left her mother's house. Mrs Bedford said that her daughter was away for about an hour and a half and when she asked her why she had been so long, Lizzie replied that she had been for a walk with Thompson and his girlfriend.

On 24 May Supt Pringle had visited Mrs Bedford and told her about the finding of a dead baby and her daughter's connection with the find. On the evening Mrs Bedford took a change of clothing to her daughter at the police station. She asked her daughter if Eliza

Cotton knew anything. Lizzie told her mother that Eliza knew nothing at all, she admitted having a child but would not say who the father was.

William Thompson, giving his evidence, stated that he now worked as a shop assistant with Messrs Wm. Wood in North Shields but before that he worked at the shop in South Shields. It was here that he became acquainted with Lizzie Harris. He denied seeing Lizzie on 23 May, he said that she had not come to his house or delivered him a parcel.

Sergeant Loadman gave evidence of his examination of the body when it was brought into the police station after being found in the back of High Street, Wallsend on Sunday 22 May. He said that a piece of cloth had been forced into the child's mouth. On 24 May at Mrs Cotton's house he discovered a piece of cloth of the same material and colour as the underclothes that the child's body had been wrapped in. On the same day he saw Lizzie Harris in Clayton Street, Newcastle, she denied that she had had a child and that the underclothing was not hers.

Dr. Forrest, after examining the body had said that the death was due to suffocating caused by a piece of cloth inserted into the baby's mouth. Also, after examining Lizzie Harris he said that she showed signs of having recently given birth.

Supt. Pringle told the court that he cautioned Lizzie Harris and charged her with the murder of her child. He said that Lizzie Harris, at the time, made no reply but later said;

"Mind, Thompson knows nothing about this".

"He has nothing to do with it". "Thomas Anderson is the father."

"I did bring the parcel to my mother's on Saturday night and I took it away the next morning."

"I had the child a week past Thursday".

Lizzie's trial was set for 1 July 1910 at Northumberland Assizes before Lord Coleridge.

At Lizzie's trial the evidence was repeated as that given at the inquest court. Mr Jardine prosecuted and Mr Griffith Jones defended. The case for the Crown was that the child was healthy and had a separate existence and that death was caused by suffocation by a piece of cloth being forced into it's mouth to still the cries of the child and that it was a grossly negligent act.

The case for the defence was that the child did not have a separate existence.

Lizzie Harris was found not guilty of murder but guilty of manslaughter. Lord Coleridge sentenced her to one month's imprisonment.

TWIN DEATHS

OCTOBER 1910

On the afternoon of October 5, 1910, Mr A. T. Shepherd, Deputy Coroner, conducted a Coroner's enquiry at the Police Buildings, South Shields, into the death of two newly born children. At the time of this enquiry the mother of the two children, Mary Hudson, of 4 Salem Street, South Shields, was lying very critically ill. Mr Shepherd hoped that she would recover, as he would want some evidence from her.

P.C. Cox, from the coroner's office gave details of the case. Acting on information he had received that morning he stated that he went to 4 Salem Street where he found the bodies of two newly born children, one male and one female. Both the babies were lying in a corner of the scullery, and were covered by a red flannelette petticoat. Both bodies were badly decomposed. He also discovered that the woman, Mary Hudson, who lived in the downstairs part of the house, was very dangerously ill. After examining the bodies P.C. Cox handed them over to Dr O'Callaghan for a post-mortem examination. The doctor, after the post-mortem, had informed P. C. Cox that both children had been born alive and had breathed.

After hearing the circumstances of the discovery and evidence from P. C. Cox, Mr Shepherd adjourned the enquiry until such a date as to the recovery of the mother, Mary Hudson.

Before she could be questioned, Mary Hudson died on October 12 from blood poisoning.

Mr A. T. Shepherd reopened the inquest on October 24, 1910. On that day Dora Sangster the thirteen-year-old daughter of Mary Hudson gave evidence. She stated that she lived with her step-father, William Hudson, a seagoing fireman, in Waterloo Vale, South Shields, but that they had both previously lived at 4 Salem Street, South Shields, with her mother, Mary Hudson.

Dora Sangster said that her mother was unwell in the early part of September. On September 22, during the night, her mother had asked for a cup of tea. When Dora had taken the tea to her mother's room, her mother had got out of bed and went into the yard, presumably to go to the toilet, After a while Dora had got concerned about her mother, who had not yet returned. She went to the outhouse to see if anything was wrong but was told by her mother to go back inside the house. Again, after short while, Dora went to go to the outhouse but only got so far as the back door where she had met her Mother who collapsed into her arms. Her mother told Dora that she, the mother, would get transported but did not say what for. Dora then went to the washhouse where she noticed bloodstains. On her return to the house she found her mother in the scullery with blood on her hands. Dora managed to get her mother to the bedroom and put her to bed.

Dora suggested calling in a doctor but her mother refused to see one. Dora, on going to the kitchen, after putting her mother to bed, heard noises very similar to children crying,

coming from the scullery. She went and told her mother about this but was told that it was only some cats. Dora suggested that if her mother would not see a doctor then some neighbours should be called in. Her mother threatened that she would murder her if she did such a thing. However, as her mother was not showing signs of recovery, the neighbours were eventually called in on 4 October and the doctor was subsequently consulted.

The coroner showed Dora the petticoat that was found wrapped around the bodies, and Dora identified it as the same one that her mother was wearing on the night she went into the washhouse.

Mary Ann Wood, who rented a room at 4 Salem Street, told the coroner that she was the one who originally found the bodies of the two babies wrapped in a petticoat in the scullery on October 4. After finding the babies she questioned Mary Hudson about the find. Mary had admitted that the babies were hers and that she had given birth to them in the outhouse. She then put them into her petticoat and hid them under her clothes until she concealed them in the scullery.

Edith Reed of 5 Salem Street stated to the coroner that Mary Hudson had admitted to her that she was the mother of the babies and that she never intended that they should live. Mary Hudson had told her that after they were born they began to cry so she put her hand over their mouths. She then said that it was her intention to bury them one at a time when she was well again.

Dr Galloway, giving evidence, said that his post-mortem of October 5 showed that the two babies were very much decomposed and that there were no signs that any attention had been given to the two babies after birth. Both babies had been alive at birth and had been breathing. The cause of their death was lack of attention and suffocation shortly after their birth. He also stated that Mary Hudson, the mother, had died of blood poisoning.

In his summing up, the Deputy Coroner, Mr Shepherd, said that if the witnesses were to be believed it was perfectly clear that both children were murdered shortly after birth. He commented that it was very extraordinary that there was so many of these cases in South Shields. In this case, if Mary Hudson had lived she would have gone to trial for the murder of her two children and that perhaps it was a good thing that she had died.

A verdict of murder was given against the mother, Mary Hudson.

CONCEALMENT OF BIRTH

MAY 1917

Before the South Shields Bench today, the Mayor presiding, Mary Stone, aged 21, a single woman lately residing in lodgings in Saville Street, was charged with having endeavoured to conceal the dead body of an illegitimate male child between 19 March and 22 April.

Mr J. M. Smith, who appeared for the prosecution, said the circumstances were very painful, but he thought the Bench would come to the conclusion that the facts were clear and that they would have no alternative but to commit the accused for trial to the next Assizes. At the time of the alleged offence, the accused, who is a single woman, was engaged as a pay box attendant at the Queen's Theatre, Mile End Road. On 5 March last she took an attic from a Mrs Alice Wawn, who resides at 23 Saville Street. She only went out at night and that was presumably to attend her duties at the theatre, returning about 11 o'clock.

On Monday, 19 March, she returned an hour earlier than usual, and next day did not go out at all. On the Wednesday afternoon, about 3.30pm Mrs Wawn went up to the attic and saw the accused, who complained that she had been ill. She remained in her lodgings all that week, resuming her employment on 26 March. On April 9 she was discharged from the theatre, and on the 19 of the same month she received notice to leave her lodgings, but said she would return in the evening at 9.30 for some parcels. She did not come back, however, and on the Sunday Mrs Wawn went up to the attic and had a look round. On a table near the window she found a parcel wrapped up in blue paper, and tied with tape. She partially opened the parcel and discovered inside some female clothing, amongst which she could see the head of a child. She communicated with the police, who investigated the matter and took possession of the parcel, which was found to contain the body of a newly-born male child. On Monday 23 April, Mrs Wawn met accused in the street. Accused said 'Can I come up and get my clothes?' The landlady told her what she had found, and advised her that she had better go to the police. An inquest in accordance with the medical evidence, namely, that death was due to haemorrhage due to lack of attention at birth. On the 15th inst. accused was charged with having endeavoured to conceal the birth of the child and she made no reply.

The evidence given at the coroner's inquest was repeated, the witness being Alice Wawn, wife of a soldier, living at 23 Saville Street; George Wm. Hunter, manager of the Queen's Theatre; Dr WM. DaIziel Sutherland, police surgeon; and Detective-Sergeant Pilling.

In reply to Mr C. W. Taylor (one of the magistrates), Detective Pilling said the parcel, which contained the body, was lying quite openly on the table in the attic for anyone to see.

The Bench remanded the case until Saturday to enable the depositions to be prepared and read over to the witnesses, with a view to accused being committed for trial.

Saturday May 19, 1917

In the case of Mary Stone (21), a single woman, charged with the concealment of the birth of her newly born male child, the depositions were read over to the various witnesses at the South Shields Police Court today, the Mayor (Ald. Wm. Allen) presiding, which the accused was formally committed to take her trial at the next Durham Assizes. Mr J. M. Smith appeared for the prosecution. The accused made an application to the Bench for legal aid under the Poor Prisoner's Defence Act. The Mayor thought it was a proper case in which to grant legal assistance and allowed the application.

WASHHOUSE BATTLE

AUGUST 1906

Catherine Humble, 28, married, of 40 Bede Street, Tyne Dock, was charged on remand at South Shields Court on 22 August with having inflicted grievous bodily harm upon Ada Proudfoot on 7 August. Presiding was Ald. J. Bowman.

The complainant, Mrs Ada Proudfoot a widow of 13 Bede Street, Tyne Dock, stated that at 5.30pm on Tuesday, 7 August she and the accused, Catherine Humble were assisting a Mrs Ellen Keasey to do her laundry in the washhouse. During the washing she had occasion to speak to Mrs Humble about her use of bad language in front of her children. Mrs Humble had answered back by saying "You be -------- and your children" she then struck Mrs Proudfoot twice, the second blow knocking her down. She then took Mrs Proudfoot by the hair and 'brayed' her face on the cement floor. On Mrs Proudfoot getting up on her feet again the accused smashed an empty lemonade bottle over Mrs Proudfoot's head felling her to the ground. As Mrs Proudfoot lay on the floor Mrs Humble repeatedly assaulted her with the neck end of the broken bottle, At that point she became unconscious.

As the assault was going on somebody had ran to get a policeman. Police officer, Sergeant Wm. Armstrong then arrived and attended to her head, and then had her conveyed to the Tyne Dock Police Station, where Dr. Sutherland, the police surgeon attended to her. She was afterwards taken to the Workhouse Hospital, and remained there until Monday last.

Dr. Sutherland, the police surgeon, stated that very shortly after the occurrence he saw Mrs Proudfoot at the Tyne Dock Police Station. There was a wound across the left side of her head above the ear 1½ inches long, penetrating to the bone, and on the back of her left shoulder thee was another extending downwards and bleeding freely. There were several superficial wounds on her arms. She had lost a lot of blood, and was in a dangerous condition. He had examined her this morning, and she was in a very weak state, and it would be sometime before she was completely recovered.

He saw the accused at the same time, and she had a black eye, some scratches on her face, and a cut finger.

Mrs Ellen Keasey of Bede Street, Tyne Dock, in whose washhouse the incident took place, then gave her account of the incident. She stated that it was Mrs Proudfoot who struck the first blow. Mrs Proudfoot had said to the accused "Have you been saying I carry on with my lodger?" then struck the accused in the mouth. The two women closed and fought together until they fell to the ground. They still continued to struggle, and both exchanged blows, and pulled one another's hair. When they came out of the washhouse shortly afterwards, they both shook hands, and the accused said to Mrs. Proudfoot "Are you paid?" Mrs. Proudfoot said "Yes", adding "Kate, we've had many a drink together; we will have another." They walked away together and Mrs. Keasey went into her house. Ten or twenty minutes

afterwards she saw Mrs. Proudfoot just inside the yard door with blood streaming down her face. She was waving her arms about and challenging Mrs Humble to come on.

Mrs. Keasey stated that she never saw any bottle being used, but she afterwards saw a broken lemonade bottle in the washhouse, which was all right when she went upstairs.

Mrs. Keasey went on to say that she knew for a fact that the two women had been drinking together all day. They were mad drunk and did not know what they were doing.

When asked by Ald. Bowman what state she herself was in at the time, she replied "Just as I am now, Sir."

Mrs. Proudfoot's son said that he saw his mother and Mrs. Humble fighting and that Mrs. Humble had thrown a bottle at his mother.

Sergeant Armstrong said that when he took Mrs. Humble into custody the middle finger of her left hand was nearly severed. When he charged her she had replied, "It was in self defence."

The court reduced the charge to one of assault and sentenced Mrs. Humble to prison for four months.

TEN THOUSAND FELLOWS UPON ME

MARCH 1923

An exciting struggle with a prisoner armed with a knife was described to the South Shields Bench yesterday afternoon when a powerfully built coloured man named John Lowgower was charged with having unlawfully attempted to feloniously wound P.C. Ainslie to prevent apprehension and further with having feloniously wounded Walter Callaghan with intent to do him grievous bodily harm on 19 March.

P.C. Ainslie said that about 11.35pm on the Monday night while on duty in East Holborn he saw the prisoner going up the bank. Knowing him to be a reputed thief, witness kept observation upon him and saw him try the door of Levy's outfitter's shop.

Prisoner afterwards walked further up Holborn and looked over the top of a screen into a window. Witness then lost sight of him but from what he was told by a witness named Brannen he proceeded in the direction of Academy Hill and searched for the prisoner for about twenty minutes.

He eventually found him concealed behind a door and he ordered him to come out. Witness took hold of the prisoner and told him that he was going to arrest him for loitering with intent to commit a felony. Prisoner replied, "You'll not take me", and after they had gone about 30 yards he commenced to struggle violently.

Throwing witness off, accused pulled out a knife and made several stabs at him, shouting, "I'll kill you!" He then ran away in the direction of the Mill Dam, where witness again closed with him. He drew his staff and warded off the blows, which the prisoner aimed at him with the knife, but he could not knock the knife out of his hand.

The witnesses Callaghan and Grant then came up and the prisoner ran up Nelson's Bank into Pleasant Place and down the steps into Commercial Road. He was chased into Victoria Road, where witness again closed with him and the prisoner commenced to struggle violently and made several plunges with the knife, shouting, "I'll murder you!" striking out with the knife at all angles. "He fought like a lion – absolutely."

Callaghan then came up and witness shouted, "Look out he's got a knife." Prisoner stabbed at Callaghan and cut him on the arm. Witness continued to struggle with him, using his staff, and when P.C. Flegg arrived upon the scene the prisoner was overpowered and the knife taken from him. He resisted violently all the way to the police station.

The officer's clothing was cut in three places, but he escaped bodily injury himself although Callaghan was cut and bled profusely from a wound in the left arm.

Walter Callaghan, general dealer, of 26 Mill Street, spoke to going to the constable's assistance. When the prisoner was overtaken in Victoria Road he still had the knife in his hand and he was stabbing at the constable. Witness rushed forward and the prisoner stabbed him on the arm. The wound bled profusely, and after first aid had been rendered by

the police the injury was dressed by Dr Marks.

In reply to the prisoner, whose left hand was bandaged, the witness denied having struck him with a door hinge.

"Did you not have a door hinge in your hand?" asked the prisoner.

"No," replied the witness. "I wish I had, I would have hit you right enough."

"Did you knock my teeth out?"

"No."

James Brannen and William Grant, of 33 East Holborn, also gave evidence.

P.C. Flegg deposed to hearing P.C. Ainslie whistling for assistance. When he arrived upon the scene the prisoner was making desperate stabs at Ainslie with the knife, and when witness tried to close with him he rushed towards the wall to try and get his back to it. Witness succeeded in getting hold of him and with great difficulty forced the knife out of his hand. He resisted like a madman all the way to the police station.

P.C. Thom said that when the prisoner was brought into the station the officers were in an exhausted condition and Ainslie practically collapsed. When charged with loitering, the prisoner said: "I did not intend to steal. I was watching them that does steal."

On the attempted murder charges, he replied, "There was ten thousand fellows got upon me. I did not try to stab you (the officer). There was too many. I didn't know one from the other." Lowgower then declared that he was only trying to defend himself.

Dr Marks said Callaghan was suffering from a punctured wound on the left shoulder half an inch long and two inches deep, penetrating into the muscle. It was not dangerous. The forefinger of prisoner's left hand was broken, and he had lost some teeth.

Prisoner denied having attempted to stab the constable but admitted cutting Callaghan. He said that all his teeth had been knocked out and his finger was broken.

Prisoner was committed for trial at the Assizes and the chairman, Mr R. E. Binks, congratulated Callaghan on the great courage he had displayed in going to the assistance of the constable. The Bench were also grateful for the services rendered by Grant and Brannen.

The chairman complimented P.C. Ainslie on his courageous conduct in effecting the arrest of a very dangerous prisoner and he expressed the hope that the authorities would take note of his services.

DOUBLE THROAT CUTTINGS

JUNE 1928

On 13 June 1928 at the Police Court, Mr Thomas Hancock, aged 39, single, unemployed miner of 123 Campbell Street, South Shields, was charged with having attempted to murder Ellen Bran Hale, aged 32, married, of 111 Campbell Street. He was additionally charged with having attempted to commit suicide.

The accused, who was not legally represented, appeared in the dock with his neck bandaged. Mrs Hale, who was pale and seemed weak, was accommodated with a seat while she gave her evidence. The Magistrates were Ald. J. R. Lawson and Mr Noble.

Prosecuting, the Chief Constable Mr William Scott, said that Hancock had been in the habit of visiting Mrs Hale's home for some time, and, he alleged, they had been on intimate terms. On 23 May the prisoner was alleged to have said to the woman's mother in Back Campbell Street, "You will be losing your daughter soon."

At that time Mrs Hale came along. It was not known whether Mrs Hale heard or not, but Hancock was alleged to have said, "I am going to cut her throat." The mother said, "Dear, forbid."

On 27 May the prisoner was seen sitting in his shirtsleeves near Mrs Hancock's home. He sat for about two hours and then went away, returning at different times.

At 6.30 in the evening Mrs Hale was seen to go to the sink in the yard to empty a pail of water. A Mrs Goodwin, who lived in an upstairs house overlooking the yard, saw her there. She heard Mrs Hale say, "Don't Tommy! I'll tell George." Then Mrs Hale went back upstairs. At about 8.30pm Mrs Hale went downstairs again to get some water at the tap.

When she was there she saw the prisoner close to her, and she felt something across her throat. She put her hands up to her throat and ran upstairs.

She was found to have a serious wound in her throat and was bleeding profusely. The police were notified and Dr O'Callaghan was summoned, and the woman's injuries were attended to.

P.C. Addison subsequently went in search of Thomas Hancock whom he found at his lodgings at 123 Campbell Street, with a bandage around his throat. The constable removed the dressing and found he had a slash across his throat.

The officer informed him he was making inquires regarding a woman having been wounded at 111 Campbell Street, remarking that he understood Hancock knew something about it. The accused made no statement then, but afterwards inquired how she was. The officer informed him she was in a very bad state. Hancock said. "I hope she will be worse."

A blood stained razor was handed to the constable, and he was told that the prisoner had appeared to be very restless during the day, and was in and out of the house several times,

and had several times been seen to go to the cupboard where the razor was.

Both Mrs Hale and the accused were conveyed to Harton Hospital. The woman was in a very critical condition for some time, so much so that a statement had to be taken from her in the presence of a magistrate and the prisoner.

The Chief Constable alleged the crime was premeditated. Hancock, the evidence would show, had intended to commit it because he had told Mrs Hale's mother that she was going to lose her daughter, and that he was going to cut her throat.

The first witness called was Mrs Hale, who stated that she had known the accused for about 13 or 14 months. When he visited her house it was chiefly in the evenings.

Witness spoke to having overheard the threat alleged to have been made regarding her by Hancock on 23 May. The accused, she alleged, had also threatened to kill her the day before. On that occasion she had refused to allow him in her house. He went upstairs, however, and she followed him. In the house he threatened to "do her in," she alleged. She thought he was only joking.

Speaking of the affray, Mrs Hale said Hancock came behind her while she was stooping at the tap. She put her hands to her throat and discovered it had been cut. She looked round and saw Hancock had gone. She then ran upstairs, and picked up a shirt and tied it around her neck.

Witness said her husband had not worked for about eleven years owing to consumption.

"What about relations between the prisoner and yourself?" asked the Chief Constable "Did you put the prisoner in your husband's place?"

"Yes."

Hancock, added witness, was a quick-tempered man and considered she had no right to speak to anyone but him.

The woman's husband, George Hale, said that during the last six months the accused had been visiting his home almost nightly.

He was in the kitchen at his home on 27 May when his wife came in. She was bleeding profusely from a wound in the throat. He wrapped a cloth round it and sent for a doctor and the police.

Robert Coxon, Hancock's landlord, spoke to having found the accused standing over a bucket bleeding from a wound in the throat. Hancock threw a razor on the kitchen floor. Witness said to the prisoner, "What have you done that for?" He made no reply. After Coxon had bandaged his throat Hancock said, "I have cut Mrs Hale's throat."

"Are those his words?" asked the Chief Constable.

"Yes"

Dr Shanley, medical officer at Harton Hospital, gave evidence as to the serious nature of Mrs Hale's wound and the dangerous condition she was in.

P.C. Addison gave evidence of his visits to both 111 and 123 Campbell Street after the affair. When at Hancock's request he aquainted him with Mrs Hale's condition, he said, "It is a pity she is not a sight worse."

P.C. Addison went on to say that the prisoner was conveyed to the same hospital in the same ambulance the witness assisted him to undress, and while removing his trousers the accused said, "Take care of those trousers. There is evidence on them. It will show you what sort of woman she is."

When he was charged with attempted murder he replied, "I plead guilty to that."

To the charge of attempted suicide he replied, "That's right."

This concluded the evidence. Hancock was then formally charged and asked if he had anything to say.

"I do not wish to say anything." He replied.

The Clerk: "Do you wish to call any witnesses?

"No, Sir."

Hancock was committed for trial at the assizes.

On Monday 25 June Thomas Hancock appeared at the Durham Assizes charged of having attempted to murder Ellen Brand Hale. He pleaded not guilty and applied for legal aid, but the request was not granted.

Mr Charlesworth, who prosecuted stated that Mrs Hale lived with her husband at 111 Campbell Street, South Shields. Since September last there had been an intimate relationship between her and the accused, the latter regarding himself as an acceptable lover.

He was exceedingly jealous of the woman and apparently the two had several "tiffs." On 23 May the accused said to the woman's mother, "You are going to lose a daughter soon. I am going to cut her throat this weekend."

Four nights later Mrs Hale was in the back yard in the act of drawing water when the accused, it was alleged, cut her throat, and inflicted a serious wound extending from ear to ear. She was taken to hospital, and but for prompt attention she would have lost her life.

A man named Coxon subsequently found the accused, who was stooping over a pail in his own house. His throat was cut and he stated that he had cut Mrs's Hales throat.

Mrs Hale, whose throat was bandaged and whose voice was scarcely audible gave her evidence from the Judge's Bench, standing close to the jury. She told of her relations with the accused, and said that on the night in question she was in the backyard waving to her daughter when the accused enquired, "Who are you waving at?" Immediately afterwards her throat was cut.

The accused became very excited during the cross examination of the woman. Mrs Hale agreed that Hancock's threat on 23 May was regarded as a joke. The prisoner accused the woman of tantalising him and waving to men. She replied, "I was waving to my daughter." The prisoner answered, "I know that now but to my sorrow."

Mrs Hale in reply to further questions said that she had told the accused that he had had her "scared out of her life for months."

She collapsed on leaving the bench and was led from court.

George Hale, the husband then gave evidence. He explained that he had known the accused for 11 months and expected him after supper almost every night. Hancock again became extremely excited, and he and Mr Hale engaged in a wordy dialogue in the course of which Hancock remarked, "I have been as good a friend to you and your wife as ever you have had. I have begged and stolen for you.

Mr Hale: "For me?"

Hancock: "Well, for your wife."

Mr Hale: "Without my knowledge. What have you stolen? Let's have it out. You have been too cunning for me.

His lordship put a stop to this rapid exchange of questions and further witnesses were called. These included Dr Shanley, who stated that when Mrs Hale was admitted into hospital she was in a critical condition. At one time it was feared she would die, and her depositions were taken.

The constable who arrested Hancock stated the Hancock asked as to the condition of Mrs Hale. When told she was in a bad way he exclaimed, "It's a pity she is not a sight worse."

Hancock, speaking from the dock, made a remarkable statement in the course of which he alleged that Mrs Hale was trying to make a fool of him and wanted to "get shot" of him for someone else.

The jury returned a verdict of guilty and a police officer stated that Hancock had seen active service with the Royal Garrison Artillery in France, Egypt and Gallipolis, and was a man of temperate habits. He had not worked since the dispute at Hilda Colliery in 1925.

Mr Justice Mackinnon, addressing the accused, told him he was extremely fortunate that he had not found himself charged and convicted upon an even worse offence. It was nothing but good luck that Mrs Hale had not died from the injuries he inflicted upon her, and his only excuse was that he was jealous of her.

So strange and dreadful was the offence that one might doubt whether the accused was sane, but so far as could be ascertained the state of his mind was not questioned. If there was such a doubt the matter would be carefully looked into.

His lordship passed sentence of five years penal servitude.

Hancock, glaring at Mrs Hale, exclaimed: "Satisfied?" As Hancock was led below a woman left the public gallery sobbing.

LIGHT LIST AT DURHAM QUARTER SESSIONS

JULY 1920

There were only six cases on the calendar at Durham Quarter Sessions yesterday, and in three the persons concerned had been found guilty at petty sessions and sent forward for sentences.

Sir Francis Greenwell, who presided, in his charge to the Grand Jury, said it was a matter for congratulations that the number of persons was less than half that at the corresponding sessions a year ago. It seemed to him that considering the number of people out of work and to whom the adage about "idle hands" might be applied, there was no crime in the county of the class dealt with at Quarter Sessions. At the same time it was also a matter for congratulation that cases of drunkenness were going down by bounds. In addition, all the persons who had been placed on probation were doing well, with one exception and the man in that case was to come before the court that day.

The grand jury found true bills in the three cases submitted to them and Sir Francis, in discharging them, remarked. "This, I believe, constitutes a record. I cannot recall an occasion when the Grand Jury has been discharged before the business of the court has actually begun.

Mr Frederick Jefferson, of South Shields, the foreman, mentioned that several members would like permission to see through the goal.

Sir Francis replied that if the Governor does not show any signs of dissent, you may.

CASES

George Robert Leach, aged 16, a miner, was ordered three years detention in a Borstal Institution. He had been convicted at South Shields of stealing 11s 1d the monies of the local Gas Company.

Det. Atkinson informed the court that the youth was first convicted of theft when 10 years of age. In the same year he was again before the South Shields magistrates for theft and was sent to an industrial school from which he absconded on seven occasions. When he returned home his father found him employment at Whitburn Colliery, but he was discharged for using bad language to his foreman. Later he was over for the theft of a bicycle.

In January last he stowed away on board ship and left the vessel at Genoa. The British Consul at Leghorn found him passage home and in April, during the temporary absence of his parents, he broke the padlock off the gas meter, absconded with the contents, and gave himself up to the Gateshead police the following day. The officer described the youth as of a roving disposition and beyond the control of his parents.

Barbara Greener, aged 15, a domestic servant convicted at Kyo, was sentenced to three years in a Borstal Institution.

The courts adopted a similar course in the case of Jane Brown, 19, a domestic servant who was convicted at South Shields of the theft of a coat, the property of Joseph McQuade, and the theft of a coat, the property of John George Wilson. Detective Inspector Wilson described Brown as a cunning thief.

Harry Offord, 39, a labourer admitted a charge of stealing a motorcycle at Durham. Sentence of 12 months imprisonment was passed.

TROUBLE AT HOME

1905

"How is it," the question is often asked, "there is so much matrimonial trouble at South Shields?" The query is somewhat of a puzzle, and it is not surprising to find that the answer is rarely a satisfactory one. It is an undoubted fact that the Borough Police Court is noted for its "man and wife" cases, indeed so much so, that in some quarters it is known as the Shields "Divorce Court."

Almost everyday in life stories of marriage misfits are inflicted upon the long-suffering magistrates and public. Some say that the publicity given to matrimonial cases in the press accounts for the large number of cases brought before the magistrates, and to some extent this may be true. It should be remembered that there is always a class of people who are extra ordinarily anxious to read about themselves in the columns of a newspaper. Possibly with this many a trifling case, which to other people is a waste of time to hear, is brought before the magistrate. Let us take an ordinary Court day.

On the magistrates taking their seats, and other court officers shouting "Are there any applications?" there are generally a few women, mostly unkempt looking, who seek summonses against their husbands for a variety of causes, 'desertion,' persistent cruelty,' 'failure to maintain,' etc. As a rule most of the applications of this sort are granted but the fact that most of them never trouble the magistrate again is explained when it is stated that the fee for taking out the summons is rarely forthcoming.

The middle-aged woman with a baby in her arms tells the Bench the number of years she has been married and what children she has. "How long has he ill-treated you?" asks the all-important official, the clerk. "Ever since we were married, Sir," is the usual reply. She then proceeds to enumerate the acts, which she alleges constitutes persistent cruelty, winding up with a description of how he pulled her out of bed the previous night and put her out of the house. "Is ther no chance of making up your differences!" the chairman asks. "None Sir," replies the complainant. "I have stood it long enough and I cannot bear to live with him any longer." The husband then proceeds to give his view of the case. How his wife neglected the house, the children, never had his meals ready, continually running home to her parents, how she 'drank like a fish,' and how he had to stand the interference of his mother-in-law. These rashly made statements are vigorously, and hysterically denied by his wife. "Well," the chairman says, "it seems a pity to separate you after these years of married life." Seeing no signs of reconciliation, the magistrates grant a judicial separation, ordering the defendant to pay so much per week to his wife, according to his earnings.

"A very sad case, but what can you expect? Two young people having married without studying one another." Such is the comment of the presiding magistrate in a case dealing with the home troubles of a young and foolish couple. With a ridiculously small case to

think of getting married on, an apprentice fitter wooed and won a girl, as big a fool as himself. After a week of married life in a one-roomed house the trouble started, and for a time the girl-wife continually bore marks of her husband's ill usage in the shape of black eyes. So, after the space of six months of married life, both came before the magistrates with their grievances. In addition to applying for an order of separation the wife charges her husband with assault. The solicitor who is conducting her case is a specialist in affairs matrimonial, and conducts the examination of his client in a way to obtain admiration. The case is not altogether without its humour, a hearty laugh being caused by the defendant saying he was an Irishman, in answer to a question by the Chairman as to what he was to business. Again a good deal of merriment is caused by a reply of the complainant and the retort of the solicitor. Asked by the legal gentleman where her husband struck her; the girl replied "At the bottom of the stairs." "Oh," is the sarcastic comment "and what part of the body is that?" Eventually, after a hearing extending over a considerable time, the case is adjourned for five weeks to see if the couple can make it up between them. "Exercise more toleration towards one another," is the parting advice of the Chairman.

Then comes one of the rare cases with 'the man' as the complainant. He seeks to be separated from his wife on the grounds of her being a habitual drunkard. "She is in and out of the pubs all day long, your worships. When I come home, after a hard day's work, there is never any food ready, and I've just got to fish for myself. The children are neglected and I cannot stand it any longer. It is all the cursed drink, if she could leave that alone she would be a good wife and mother." This is the neatly condensed story of a respectable workingman. A lady-like and retiring looking woman, the defendant, appears to be one above habitually visiting public houses. But, then, appearances are deceptive. She denies the drinking, saying she couldn't obtain it if she wanted it, as her husband didn't give her any money. The husband then explains that owing to his wife's drinking habits he was forced to stop giving her his wages, and had to take home the necessities of life himself. His application is granted. He agrees to allow his wife 10s, and on further application has the children entrusted to his care. Then a truly pitiful scene is enacted. Drunken though she may be, she is a mother and she pleads earnestly and violently in turn for the magistrates to allow her her "bonnie bairns." She is told she ought to have thought of the consequences before starting drinking, and is then led out of court on the wave of hysteria.

This is a blend of the matrimonial cases, which occupy the attention of the South Shields magistrates. To those who are continually hearing them, they lose their interest, but one sometimes cannot help pitying the visit to court of the care-worn wife of the brutal labourer, or the honest and hardworking mechanic who has the misfortune to be the husband of a dissipated woman. A very happy way the magistrates have of disposing of simple matrimonial cases is by adjourning them for five weeks to see if the differences, which stand between the happiness of man and wife, cannot be made up. In almost every instance this decision has the desired effect, nothing more being heard of the cases, cold water, practically speaking, having been thrown over both parties. Truly the number of wives and husbands, particularly the former, who come to have the merit of their cases weighed in the scales of justice at South Shields, is great.

Now that you have read this book, you may believe that South Shields, between 1900 and 1925, was all bad old days. Believe me, they were not. During my research I found plenty of evidence to show that there were more good old days than bad ones. Enough to convince me that, despite what I have written, the saying 'Canny Old Shields' is still ringing true.

Do not forget the subject I chose was Death! It is never a happy one.

LIST OF SOURCES

The South Shields Gazette
Sunderland Daily Echo
The Independent
South Shields Corporation Minutes of Proceedings
100 Years of Local Government 1835–1935, South Shields
Corporation Borough
Reports of The Chief Constable 1900–1925
Annual Report of the Police Establishment 1900–1925
Annual Report of the Medical Officer of Health 1900–1925
Ward's Directory 1900–1925